IMAGES
of America

OAK PARK

IMAGES
of America

OAK PARK

Gerald E. Naftaly
Foreword by Gov. James J. Blanchard

ARCADIA
PUBLISHING

Published by Arcadia Publishing
Charleston, South Carolina

Printed in the United States of America

Library of Congress Control Number: 2012940062

For all general information, please contact Arcadia Publishing:
Telephone 843-853-2070
Fax 843-853-0044
E-mail sales@arcadiapublishing.com
For customer service and orders:
Toll-Free 1-888-313-2665

Visit us on the Internet at www.arcadiapublishing.com

*To my mother, Grace Naftaly, and my late father, William "Bill"
Naftaly, with love and appreciation for choosing to move to Oak Park.*

CONTENTS

FOREWORD

Mayor Jerry Naftaly has assembled an extensive collection of photographs and personal recollections that illustrate the seven-decade history of Oak Park, Michigan. Having had the pleasure of representing Oak Park in the US Congress (1975–1983), and while serving as Michigan's governor (1983–1991), I worked closely with Mayor Naftaly on many initiatives that benefitted the outstanding community he led for so many years. As an example, while my administration evaluated many possible locations for construction of an important new state police post, his input and leadership were essential in establishing the new Metro North Post in Oak Park.

I always enjoyed participating in Oak Park's traditional Independence Day parades and numerous other special events over the years. Each visit was like a homecoming because of my many career-related and personal memories associated with the community. The late Joe Forbes, a longtime friend and mentor who previously had served as Oak Park's mayor and then state representative, became a highly valued member of my cabinet.

As a young boy in Ferndale, I was really excited to learn that Detroit Tiger great Al Kaline lived in Oak Park. I used to ride my bike out there, hoping for a glimpse of him. Later, as governor, I got to know the baseball Hall of Famer, and we laughed about my having tried to hound him many years before. There are so many reasons that Oak Park holds a special place in my heart, as it does for so many others.

I commend Arcadia Publishing for the Images of America series and its celebration of the history of Oak Park.

— Gov. James J. Blanchard

ACKNOWLEDGMENTS

One of my ambitions has been to establish a photographic collection depicting the evolution of this community from its earliest days as a village to the present. I have been motivated and energized to create Images of America: *Oak Park* by an extraordinary response from many former and current residents.

Thank you to the many people who asked, "Whatever happened to…" They all had fond memories to share, including recollections of favorite restaurants and stores. Like me, many went through the school systems, played on sports teams, and sledded down Hamilton Hill. They all had the same sentiment: that Oak Park was and is a wonderful place.

My thanks to my mother, Grace Naftaly, affectionately called "First Mother," for her encouragement and patience. My sincere special thanks to Rhonda Scherr Traficante, who spent many hours reviewing images, captions, and material and provided much needed opinion and encouragement in helping to create the best collection possible.

Thank you to John Martin, who helped start the project; Mel Newman, for many hours of writing and editing; and Steve Knowles, who spent a great deal of time scanning and rescanning images, which included many of his personal memories of employment with the city as well as the many years of management by his father, Virgil Knowles. Thank you to Bernadine Shoults for providing a historical review of Oak Park's early years. Thank you to Richland Towers for allowing me access to the studio on Eight Mile Road. Thank you to the many people who contributed photographs and ideas, including Don and Mark Weber, Ken Snow, Burt Shifman, Rachel Rothstein McCarthy, Johanne Etkin, Dr. Chuck Domstein, Hank Becker, Ray White, Jim Hansen, Art Vuolo, Jonathan Nachman, Craig Gaffield, the John Molloy family, Debbie Shapiro Rosenberg, Paul Lubanski, Paul Vachon, Shannon Murdoch, the Glen Leonard archive, Ernie Solomon, Elizabeth Murray Clemens, and the Walter P. Reuther Library. Unless otherwise noted, all images are courtesy of city archives.

Thank you to my editors and publisher at Arcadia Publishing for their patience and support during this project. My sincere thanks and gratitude go to the people and institutions that provided me with much-needed assistance in the preparation of Images of America: *Oak Park*.

I have always believed that many people looked back on their days in Oak Park with the same sense of appreciation as my own. This has always been a wonderful place to grow up and to raise one's own family, to go to school and play in the neighborhood park, to participate in a terrific variety of recreational programs, to shop at nearby stores, and to eat at a favorite restaurant, deli, or bagel place. Yet, the level of enthusiasm and nostalgic affection expressed by so many of the people I contacted amazed me. My thanks to the people of Oak Park.

INTRODUCTION

Oak Park became a village in 1927, when voters adopted the proposed charter. In 1945, a new charter was approved to incorporate as a city. In most visible ways, the city of Oak Park was hardly any different from the village that had been carved out of Royal Oak Township 18 years earlier. The population had increased only slightly during that time. Detroit was just to the south across Eight Mile Road, but major new roads connecting the two cities were not yet on the drawing board.

However, big changes were coming. The new city's first group of elected officials recognized this by introducing the motto "City with a Future." Thousands of veterans who returned home to Detroit after the close of World War II were getting married, starting families, and buying homes on the GI Bill. By 1950, single-family housing construction in Oak Park had accelerated so quickly that Oak Park was being acknowledged as Detroit's first northwest-corridor suburb.

Residents knew the kind of hometown they wanted. In the late 1940s, they had turned back separate attempts to build a horse-racing track and an airport within the city limits. The fundamental character of the community was obviously attractive to many others as well. Oak Park was recognized as the nation's fastest-growing city in the mid-1950s.

There were some dark times for the city though. Many remember how the Crystal Pool on Greenfield Road, north of Eight Mile Road, blatantly barred African Americans and Jews from using the pool during the 1940s and 1950s.

In 1973, the city banned "For Sale" signs on residential property in response to blockbusting. Unscrupulous real estate agents attempted to create a panic when a home was sold to a member of an ethnic or racial minority. As a result, home prices were reduced. Speculators took advantage of the depressed home prices by buying the homes and selling them at higher prices. The city's ban had a beneficial effect in halting a panic. The case went to the US Supreme Court.

In August 1992, a group of about 10 neo-Nazis demonstrated on Hamilton Hill during a Yiddish concert preceding a pro-Israel rally. The hill was surrounded by 25 Oak Park public safety officers to keep concertgoers and others away. Some spectators began throwing rocks, and the Nazi group ran to a van on the other side of the hill, throwing papers out of the window as they drove away. Residents felt the officers were protecting the Nazis, but city officials commended them for keeping the protestors away from the hundreds who were there to enjoy the concert.

Progress continued over the years. The civic complex was completed, and a full range of municipal services was provided. By the 1960s, the children of many original Oak Park residents graduated after 12 years in the city school system. By the time of America's bicentennial celebration in 1976, a new generation of residents was becoming a majority. Newcomers were from an increasingly broad range of backgrounds. Over the next decade, national media publicized the extraordinary variety of cultures represented within Oak Park's population of 31,000. This rich diversity, along with the residential nature of the community and the focus on citizen services, was reflected in a new motto, "The Family City."

In the 1950s, the theme of "brotherhood" was popular. The Oak Park Association of Community Groups was formed by many of the synagogues and churches in Oak Park to promote interfaith unity.

Oak Park lacked a downtown but had many large and small shopping centers throughout the city. Residents had their favorites, and the local drugstores, restaurants, and shops had very loyal fans.

Oak Park was fortunate to have people who were willing to donate their time and talents to the city. They served on boards, committees, and commissions and assisted the professional staffs in evaluating programs and services that were offered to residents and visitors. These residents felt a strong sense of community and helped to create unique events for the city. A fine-arts fair was held above the I-696 Freeway, an unlikely place for a park. A diversity of ethnic groups came together and organized successful festivals. Library, recreation, and arts and cultural commissions brought a wide variety of music concerts and programs. The Independence Day parade, Funfests, and fireworks shows brought out the city's largest single-event crowds. Recycling commission members and others helped educate students about the benefits of recycling. The city values all of the volunteers and employees who make Oak Park "The Family City" and a great place to live and work.

Oak Park has been home to a number of people who gained national and international acclaim. Jeffrey Sachs, a graduate of Oak Park High School, became one of Harvard University's youngest economics professors. He earned distinction as a noted economist and director of The Earth Institute at Columbia University. *Time Magazine* twice (2004 and 2005) named him one of the "100 Most Influential People in the World." Robert Ettinger, known as the "Father of Cryonics," was a teacher of college physics and math. Ettinger recently passed away, and his body was frozen and placed in a cryonic capsule. Many other Oak Park High graduates have become very successful. The late Doug Fieger was a singer, songwriter, musician, and lead singer of the pop band The Knack. He co-wrote The Knack's 1979 hit song "My Sharona." Doug also joined with fellow Oak Parkers David Weiss and Don Fagenson in a group called Was (Not Was). Doug was the younger brother of attorney Geoffrey Fieger, who represented Jack Kevorkian, "Doctor Death." Their sister Beth has written for television and movies. Curt Sobel is an Emmy-winning music editor now living in Hollywood. Mark Sweet is a comedian hypnotist in Las Vegas. Longtime resident Peter Werbe hosts WRIF's *Nightcall* program, the longest-running phone-in talk show in US radio history. Another recognizable Oak Parker was Maurice Lezell, also known as legendary "Mr. Belvedere." Lezell started Belvedere Construction in 1948. Its phone number, Tyler 8-7100, and slogan, "We Do Good Work," were well known on local television. Detroit Tiger greats Al Kaline and Norm Cash called Oak Park home for a while during their careers.

Notable Oak Parkers also include broadcast veteran and building expert Murray Gula. Noteworthy athletes include high school and college basketball standout Larry Sherman who, along with prominent professional baseball players Rick Seid and Bruce Seid have been inducted into the Michigan Jewish Hall of Fame. Other inductees are coaches Howard Golding and Howard Stone, who also served as Athletic Director. Jamie Arnold and Ryan Perryman excelled nationally and internationally in basketball. The entertainment industry includes Emmy award winners Michael Loceff and his cousin, Oak Park native Joel Surnow, writer-producers of the hit Fox TV series "24". Randy Thomas, one of Hollywood's top voice-over artists, lends her distinctive voice on "Entertainment Tonight", The Oscars and other award shows. Singer Marcy Levy, known as Marcella Detroit wrote Eric Clapton's hit song Lay Down Sally. Oak Park High grad Dennis Bowles is a life-long musician and author. Marc Silver is an accomplished Jazz musician and classic guitar instruction book author. Former Oak Parkers also include Michigan Supreme Court Justice Stephen J. Markman, Judge Gerald E. Rosen, chief U.S. district judge for the Eastern District of Michigan, and Dr. Paul R. Ehrmann, DO, noted for his work in childhood obesity. Eugene Lumberg, longtime Oak Park resident who graduated from Oak Park High, taught at both Clinton and Frost Junior High Schools, obtained his law degree, and became Oak Park's distinguished city prosecutor.

The east-west I-696 Freeway runs through the city and was completed in 1990. Oak Park became the center of a network of expressways connecting locations throughout southeastern Michigan. City officials made certain that the residential, "family" character of the community was protected by successfully assuring that new parks, landscaped greenbelts, and recreation facilities would span the I-696 route.

The history of Oak Park is illustrated here by dozens of photographs taken over seven decades and reflected in the recollections of many former and current residents.

Township I North **ROYAL OAK** Range XI East

Scale 1¾ inches to the mile

The plat map of 1872 for Royal Oak Township was established as a regular, 36-square-mile civil township. Royal Oak Township began to shrink in the early 1900s with the incorporation of villages and cities. (Courtesy of www.MemorialLibrary.com.)

One

THE EARLY YEARS

The area of Oakland County that now contains Oak Park was first surveyed in 1817. Surveyors described this land to territorial governor Lewis Cass as "irreclaimable and must remain forever unfit for culture or occupation." Governor Cass, after camping in the area, noted the great royal oak trees and christened the tree and the township Royal Oak. Several thousand acres of township land were deeded by the government to Douglas Houghton and Henry G. Hubbard. When Houghton died, his land interests in Royal Oak Township reverted to the Hubbard family, who retained it until 1908. The area that would become Oak Park was known as marshlands because it was swampy, muddy, and damp and inhabited by many birds and pheasants. Some current residents still recount going pheasant hunting in the area of Eight to Nine Mile Roads and Coolidge Highway to Greenfield Road, which became the first settlement in the 1840s.

Oak Park is located in the southwest corner of what Governor Cass named Royal Oak Township. It is slightly more than five square miles in size and would become one of the most densely developed communities in the state.

In 1914, the Majestic Land Co. created the first subdivision, called Oak Park Subdivision for the abundance of oak trees. In March 1921, the Progressive League of Oak Park Subdivision was born. In the light of kerosene lamps, resolute citizens met at Mr. and Mrs. Joseph Schrader's grocery store on the northeast corner of Snyder Road (now Wyoming) and Nine Mile Road. Bernadine Shoults identified some of the first members, including Blanche and Charles Raine, Ella and Joseph Shrader, Ruth and Fred Yehle, Mr. and Mrs. James Fisher, and Mr. and Mrs. A.L. Moser. They studied the road tax laws and found the subdivision could get money for badly needed repairs. By 1924, Nine Mile and Ten Mile Roads were paved. Additionally, the Detroit Edison Co. installed poles and wires, bringing electricity to Oak Park. Bell Telephone installed telephones as far west as Eldorado Avenue (now Roanoke). In 1924, the Progressive League incorporated and became the Oak Park Community Improvement Association. It put up handmade street signs on every block.

This enlarged section from the plat map on page 10 shows the detail of how Oak Park was initially deeded and divided. The Wayne County line is at the bottom of the map, known today as Eight Mile Road or Base Line. Oak Park stretches from this line, going up along the left side, north three squares to Eleven Mile Road. It then extends to the right at varying points. In later years, a section of the township in the northwest would fight against becoming a part of the city. Oak Park pursued this for some time but ultimately dropped it, allowing people to remain in Royal Oak Township. Ironically, in 2004, this same area would petition to become annexed by the city in order to reduce taxes and improve services. In the lower left, note "B. Clinton School No. 3." Barney Clinton, a local farmer, owned this land. In 1848, he constructed and donated Oak Park's first school, seen on the next page. (Courtesy of www.MemorialLibrary.com.)

Barney Clinton, a local farmer, owned land in the southwest corner of the city that was in the Nine Mile Road and Greenfield Road area. In 1848, Clinton, with the help of two other settlers, Christopher Lando and John Granzon, constructed and donated Oak Park's first school with lumber from a nearby sawmill. The school was a one-room, small-frame building 22 feet wide and 38 feet long. It was heated by a wood-burning stove and lighted by oil lamps. Long desks, accommodating seven children, were in the center of the room with desks for two at the sides. The only road on what is now Nine Mile Road was known as a corduroy road (logs laid side by side in the dirt). The quicksand was so bad that it swallowed up the logs. The land was gradually drained and cleared. Gravel roads took the place of corduroy roads, and these were eventually replaced with concrete. As the area became more populated in 1893, it was necessary to build an addition to the school.

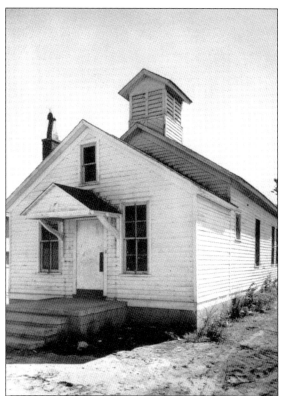

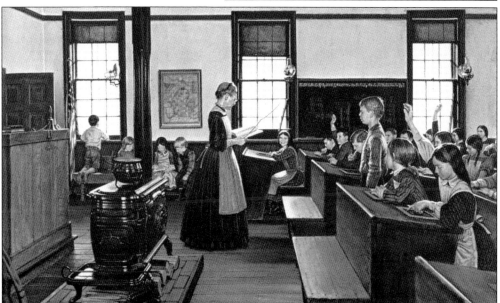

The One Room School, created by artist Robert Thom, was commissioned by Michigan Bell Telephone in 1966. It depicts the school located near Dearborn that was attended by seven- year-old Henry Ford in 1871. The school was moved to Greenfield Village in 1929. While not the actual interior of the Clinton School, it represents how the schoolroom looked, with students sharing desks. (Courtesy of the Oakland County Executive.)

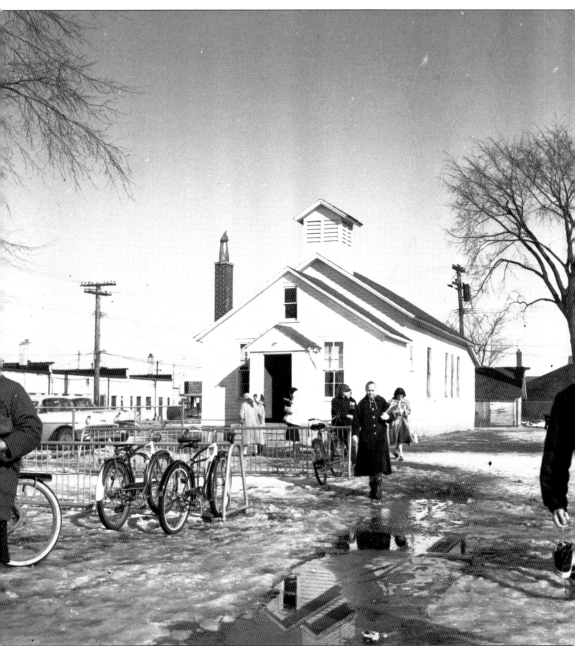

Oak Park acquired the Clinton School when the village incorporated in 1927. Peat fires, which were commonplace in the spring and often burned for months, jeopardized the building. In 1943, due to inadequate space, the school was moved to a site at Kipling Avenue just south of Nine Mile Road. An 18-foot addition was added to the rear of the school, along with a boiler room for oil heat. One of the most illustrious students was the late George A. Dondero (1883–1968), who served Royal Oak as village clerk, town treasurer, and village assessor. He would become mayor in 1921. The school has long since been demolished to make room for the school administration's maintenance building and parking lot. (Courtesy of the Walter P. Reuther Library.)

By 1926, discussions began to incorporate as a village. At a special meeting on May 19, 1926, a petition was created to incorporate the Oak Park Subdivision as a village. The county board of supervisors granted permission to put it on the ballot. That fall, the vote was nearly unanimous. A charter commission, including Charles Raine, Harold Webber, and Chester Brill, set to work on the first charter of the Village of Oak Park. They met weekly with legal, engineering, and financial advisors. They drafted a code of ordinances and a charter for their village form of government, providing for a president to be elected for one year, two commissioners to be elected to a two-year term, and two commissioners to be elected for a one-year term; a treasurer and clerk were also included in the charter. The president and commissioners were paid $2 for each meeting, with a maximum of $25 for the year. The charter provided that when the village reached a population of 1,500, the pay of officials would be increased to $5 per meeting, at a maximum $60 for the year.

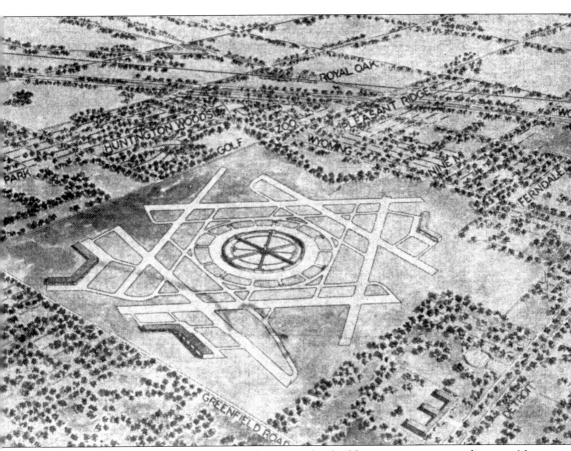

In 1932, the village commission accepted a proposal to build an airport in an area between Nine and Ten Mile Roads and Coolidge Highway and Greenfield Road. Angry Oak Park citizens, joined by Huntington Woods and Pleasant Ridge, strongly objected. Mass meetings were held at Weber Brothers' Greenhouse, and protestors filled the village hall. Commissioners, despite the objections, obtained a state license for the airport, but Oak Park taxpayers won a temporary injunction. Through the 1950s, the village commission and city council support continued with new, larger plans that extended the proposed airport eastward as shown here. "A City Within a City" described the proposed three-square mile airport project in the 1940s. Restaurants, a theater, and shops created a Rockefeller Center of the Air, with runways for large, modern planes, midfield terminals, and underground roadways for vehicles and pedestrians. Eventually, the court blocked construction of the airport.

C-95-P

Oak Park, Mich.
Monday, May,16,1927

Minutes of the First Commission of the Village of Oak Park, Mich/

Meeting called to order by President Chas. Raine, at 8:30 P.M.

Commissioners present-
James Fisher
William Cameron

Commissioners absent

James Brill
Clarence Kirby.

A motion made by Commissioner Fisher, supported by Comm.
Cameron to have the banking of the Village of Oak Park
done with the First State Bank of Royal Oak, Mich.

Yeas- Commissioners Fisher and Cameron
Nays- None
Absent Commissioners- Brill abd Kirby

Meeting adjourned at 11:00 P.M. until Tuesday evening,
May 17th, 1927 at 7:30 P.M.

Fred B. Yehle.
Clerk

Chas R Raine
President.

On March 14, 1927, the Honorable Fred W. Green, the governor of Michigan, approved the charter. The charter commission immediately set May 3, 1927, as the election date to accept or reject the charter and to elect the village officers. There were 98 registered voters, and they passed the charter. Charles R. Raine received the most votes and was elected the first village president. James Fisher, having received the next highest number of votes, was elected commissioner for a two-year term. Chester Brill and Clarence O. Kirby each received an equal number of votes and flipped a coin to see which of them should have the two-year term and which the one-year term; Kirby won the toss. William W. Cameron was named commissioner. The inaugural village commission held its first meeting in the home of President Raine on May 16, 1927, and, with two commissioners absent, they named the First State Bank of Royal Oak as the Village Bank, hired a village engineer and an attorney, and obtained the advice of the Royal Oak city manager.

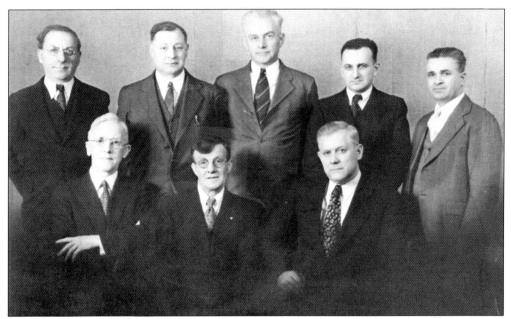

This photograph is of Oak Park's village commission and staff in 1935. Pictured clockwise from the upper left are Matthew Theato, James Fisher, Jens L. Nielsen, Fred B. Yehle, Nelson G. Lyons, Fred Feole, Alexander Garrett (president), and George F. Maxwell. (Courtesy of the *Daily Tribune*.)

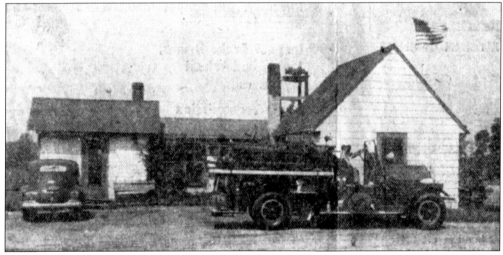

By 1928, the commission desperately needed more space but had no money for a new building. The Martz and McLaughlin Real Estate Company, located at the southeast corner of Snyder (Rosewood) and Nine Mile Roads, offered its offices and three 26-foot business lots in lieu of all taxes. Glendon J. Mowitt, who was hired in August 1927 at a salary of $3,600 for one year, had a resourceful plan. He knew of two abandoned real estate offices and the old voting booth that stood at Coolidge Highway and Nine Mile Road. One November day, a beautiful (according to the manager and commission) sleet storm blanketed the city with ice. A group of citizens and the department of public works put skids on the buildings and slid them down to the village. They slid one building to the east and the voting booth to the south of the original offices. The smaller office, placed to the south end of the voting booth, later became the police station. These "borrowed" buildings were the Oak Park Village Hall and then city hall for the next 20 years.

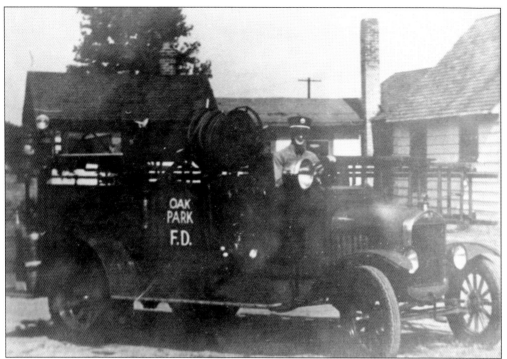

In 1930, Oak Park purchased its first fire engine, a Model T Ford, from Farmington, Michigan. Joseph Kahsin, William Bridges, and William McGill helped organize Oak Park's first volunteer fire department. Harold Philburn also served the fire department. In addition, Paul Miller was the village's first policeman, Arthur Melchert was the first uniformed policeman, and Bessie Jobin Bartholomew served as Oak Park's first policewoman.

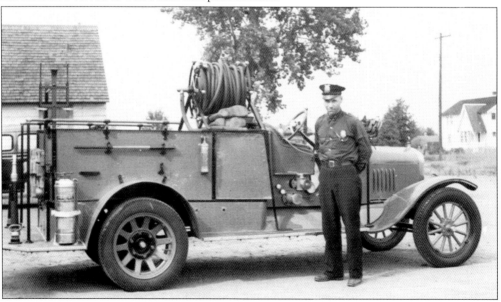

Fire chief Clarence F. Siterlet stands proudly beside the Village of Oak Park's new fire truck in 1936. The truck had been purchased from the City of Caro. The village now has three full-time firefighters and 12 volunteers. (Courtesy of the *Daily Tribune*.)

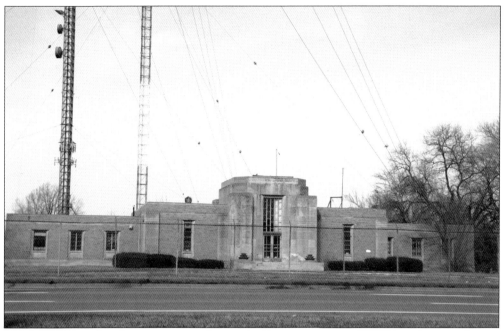

Oak Park received a pleasant surprise during the Depression years. WWJ bought several acres of ground at Eight Mile and Meyers Roads. The largest radio tower in the world was erected, which not only contributed a showplace to Oak Park but also added a substantial number of tax dollars to the village rolls. WWJ was the first radio station in Michigan and the third oldest in the United States. Racks for machine guns were attached to the outside to protect the building during World War II. Additional towers and broadcast transmission buildings are on the north side of the property. The beautiful Art Deco ceiling remains. (Author's collection.)

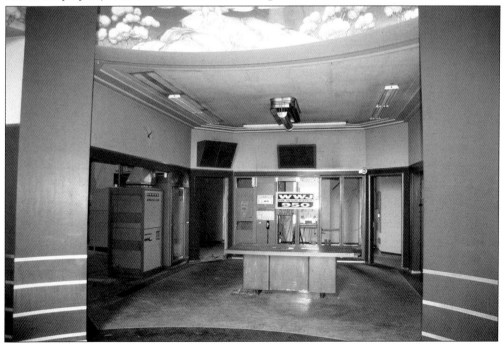

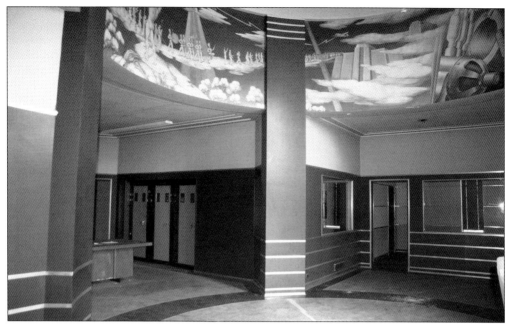

In the midst of the dusty interior, the beautiful Art Deco mural encircling the rotunda entrance has been preserved. The 1930s mural depicts the people who were on the radio station over the years, including sports figures and national celebrities. The building is no longer used. (Author's collection.)

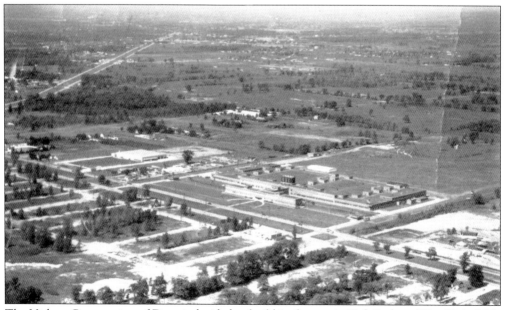

The Vickers Corporation of Detroit decided to build its factory in Oak Park on West Eight Mile Road in February 1942. This brought thousands of dollars to the village coffers and provided employment for thousands of men. The commissioners immediately took steps to have sewers installed and roads built in the area of Coolidge Highway and Eight Mile Road. An area bounded by Coolidge Highway, Eight Mile Road, the WWJ broadcasting building, and a space extending 800 feet north from Eight Mile along this whole stretch was rezoned for industry.

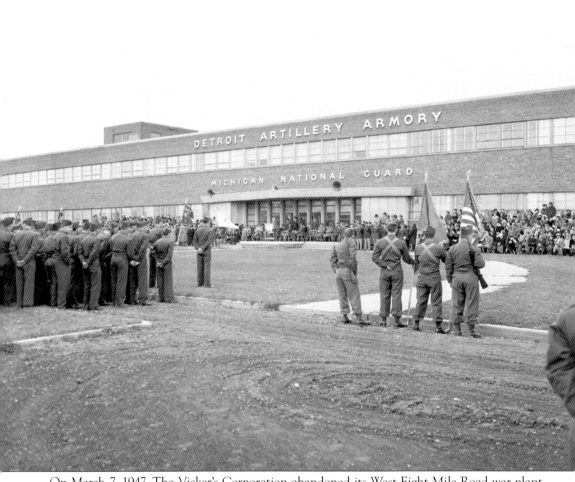

On March 7, 1947, The Vicker's Corporation abandoned its West Eight Mile Road war plant, and plans were made to sell it to the Michigan National Guard. With the sale, Oak Park would lose thousands of dollars in taxes. Protests to Michigan governor Kim Sigler (1947–1948) were unsuccessful. The mayor and city manager traveled to Washington, DC, and begged Congressman Dondero to intercede in Congress. They also sent a delegation to meet with President Roosevelt. Despite their efforts, on June 18, 1948, the plant became a Michigan National Guard Armory. With the loss of a taxable property, plans to build the new city hall were delayed. Boat and gun shows would be held in the armory in later years. (Courtesy of the Walter P. Reuther Library.)

Two

THE VILLAGE
GROWS INTO A CITY

When World War II ended in 1945, Oak Park had approximately 2,000 residents. The city experienced rapid growth with expectations for the population to reach 16,000 by the end of the year. On October 29, 1945, a new city charter was approved. John Molloy was elected the city's first mayor. The first city council members were James Fisher Sr., Fred Yehle Sr., Paul T. Commerford, and Harry G. Cousins. They appointed the first city manager, Ernest Neuman, at a salary of $4,500. He would also serve as city assessor, police and fire chief, superintendent of public works, and superintendent of welfare. The building boom began in March 1946, when Norman Glover started the first block production system of prefabricated houses on Troy Avenue between Wyoming and Republic. The houses were built in sections and unloaded from huge trucks. The walls were set up and fastened together at the corners on a cement foundation. Almost immediately more houses appeared on Saratoga, Albany, and LeRoy. Woods and swamps were cleared, farms were sold and subdivided, and roads cut through the area. Activity continued into the mid-1950s. Clinton and Jefferson Schools required additions, and a new school, Jackson, was built. Stores started appearing on Nine Mile Road and Coolidge Highway. The city council realized the need for a planning commission, zoning laws, ordinances, and business licenses. Since pheasant hunting was popular, hunting laws had to be passed. Heavy fines were administered for transporting a gun through the city, and hunters shooting birds were fined $50. Plans also began for a new city hall at Coolidge Highway and Oak Park Boulevard, but the 30 acres owned by the city was not enough. In August 1946, it proceeded to condemn two parcels of land owned by George E. Holt and Adolph Witzke.

The Oak Park News

Serving the Interest of This Community

THIRTY-SIXTH YEAR — NO. 44 OAK PARK, MICHIGAN, THURSDAY, NOVEMBER 3, 1966 20 PAGES – 10c PER COPY

FATE OF LBG RESTS ON TUESDAY BALLOT

LBG Backers Seek City Law to Limit Licenses

Voters Also Pick Area Candidates

KENNEDY CHARM permeated this area Saturday when Sen. Robert F. Kennedy included the Harvard Row Shopping Center, Eleven Mile at Lahser, on his itinerary as he zipped through the state. Southfield Mayor S. James Clarkson presented Sen. Kennedy with a key to the city as an enthusiastic crowd of suburbanites watched. Kennedy was here to urge the election of William Merrill to Oakland County's 18th District seat in U.S. Congress. Pictured L. to R., are former Gov. Williams, candidate for the U.S. Senate; congressional candidate, Merrill; and Senator Kennedy.

Three New Proposals on Ballot

Leonard Lauds Staff on Arrest Procedure

Oak Park citizens stormed city hall in protest and petitioned the State Liquor Commission.

Oak Park's first tavern, the Quonset Hut Bar & Grill, built by Charley T. Walker, opened in 1945 on Eleven Mile, west of Tyler. Oak Park citizens stormed city hall in protest and petitioned the State Liquor Commission. In 1953 a referendum was placed on the ballot to allow the sale of alcoholic beverages to be served on the premises. On November 2, 1954 the vote was 1,615 in favor and 3,826 against liquor licenses. With the expiration of their license, the Quonset Hut soon closed. In 1966, another effort to allow liquor by the glass began and supporters created the slogan "Vote Yes for LBG". On November 8, 1966, voters said "no" by an even larger margin. The votes were 8,955 against and 3,022 in favor of the referendum. City Council adopted a resolution on November 21 banning the sale of all forms of spirits for consumption on the premises.

Look Inside For:
- Guest Editorial
- Market View

The Oak Park News

Serving the Interest of This Community

CLASSIFIED ADS CALL DI 1 - 1030

THIRTY-SIXTH YEAR. — NO. 45 OAK PARK, MICHIGAN, THURSDAY, NOVEMBER 10, 1966 18 PAGES — 10¢ PER COPY

VOTERS OVERWHELMINGLY DEFEAT OAK PARK LIQUOR PROPOSAL

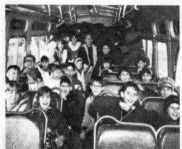

BEFORE THE SNOW flew these Oak Park fifth graders took advantage of the School District's annual camping program at Camp Tamarack. Aboard the bus, packed, and rarin' to go, this group is from Einstein School and was one of the last to enjoy the five-day camp-out activities this fall.

photo by Fred Hark

Letters Fly Over Popcorn

Mayor Joseph Forbes, well known around Oak Park for his sense of humor, still isn't laughing over Detroit Councilman Louis Miriani's crack that Oak Park Jaycees should "get a passport and visa" to enter Detroit to sell popcorn at Hudson's Thanksgiving Day parade.

Forbes and Jaycee President Michael Hochman fired off a barrage of verbal balsts at Miriani Monday, prompting the Detroit councilman to send Forbes the following telegram:

"Have you lost your sense of humor completely? If you are offended I apologize.

Louis Miriani, Councilman"

Still unsmiling, Forbes countered with his own telegram to Miriani Wednesday:

"In answer to your wire, I have quite a good sense of humor about most things. I was very much offended. I accept your apology. Please consider the incident closed.

Joseph Forbes, Mayor"

Forbes, who earlier said he considered Miriani's remark a "very irresponsible one for a person in a position," decided the matter was no joke when Miriani's remarks held up the granting of a popcorn license to the Jaycees. Miriani said Detroit Jaycees should get prefer-

WM. BROOMFIELD

SANDER LEVIN

ALBERT KRAMER

DANIEL COOPER

Oak Park Girl Hurt Seriously in Fall

A nine-year-old Oak Park girl narrowly escaped death Friday af'noon when she fell while carrying a fish bowl and severed an artery in her wrist.

Delrene Jaksina, 9, daughter of Mr. and Mrs. Stanley Jaksina, severed an artery at the wrist.

Doctors told Mrs. Jaksina they were not certain yet whether the little girl will regain full use of her hand, but that she now appears to be in "good" condition.

Oak Park public safety

Proposal Dies by 3-to-1 Margin

Oak Park voters turned thumbs down on liquor-by-the-glass Tuesday, handing the proposal a crushing three-to-one defeat.

A total of 6,905 "no" votes were cast against sale of liquor in the community, with 2,022 in favor.

Some 13,610 voters turned out at the polls, a record for a non-presidential election. The city has 18,627 registered voters.

Oak Parkers helped stem Michigan's Republican tide somewhat, as they gave a resounding victory to State Rep. Albert Kramer (67th District) in his bid for re-election, and also chalked up large margins for almost all other Democratic candidates.

Reflecting his state-wide popularity, however, Gov. Romney came close to a victory in traditionally Democratic Oak Park. He received 6,520 votes locally, compared to Zolton Ferency's slim 6,635 victory.

Other local results were: U.S. Senator G. Mennen Williams, 9,205; Robert Griffin, 4,774.

U.S. Congress (18th District) Weidenbach, 4,617; William Merrill, 7,655.

State Senate (15th District) Sander Levin, 4,354; Thomas Rowley, 2,869.

State Rep. (67th District)

McCallum, 1,509.

Municipal Judge Burton R. Shifman, also of Oak Park, trounced Eugene Moore here, 8,469 to 1,505.

County-wide results were as follows:

Romney, 160,713; Ferency, 73,766.

Griffin, 149,050; Williams, 83,571.

Broomfield, 95,357; Merrill, 47,673.

Levin, 39,584; Howley, 27,191.

Circuit Court Judicial results were: Beasley, 81,184; Roberts, 70,115; Templin, 70,260; Bronson, 65,607; O'Brien, 51,623; MacCallum, 40,572.

Probate Court finals were: Moore, 64,313; Shifman, 54,296.

Both county proposals won. The vote on establishment of a county-wide system of parks was approved, 89,049 to 64,986 and adoption of a merit system for county employes was okayed, 102,468 to 37,728.

Auto Hits Building.

3 Injured

A 25-year-old man was arrested last week after his car crashed into a building

Pupils Find School Not All Bookwork

Again this Fall several hundred Oak Park elementary students were mighty glad they live in this School District. Combining fun and games with the curriculum, the fifth grade classroom is moved outdoors. The district-wide

PTA Grps.

'Friends' Give Books to Library

Our Lady of Fatima's elementary school library recently received several sets of books from the parish's

Each year, as a regular part of the curriculum, the fifth grade classroom is moved

In 1979, Stafford's Restaurant applied for a tavern license to permit the sale of beer and wine for consumption on the premises, but the city denied it. Stafford's filed a lawsuit in Oakland County Circuit Court, but the court ruled for the city. The restaurant appealed to the Michigan Court of Appeals in 1983, but that court ruled for the city as well. The Michigan Supreme Court twice refused to hear the appeal. Oak Park continues to ban the sale of alcoholic beverages for consumption on the premises.

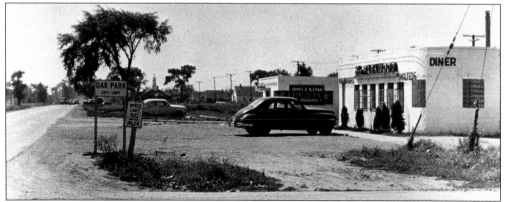

The original Parkwood Diner on Coolidge Highway at Kingston served as a landmark for over 50 years. The Stilber family opened the 42-seat diner in July 1947. They wanted a tavern, but Oak Park refused to grant a liquor license, so the establishment became a classic American diner. Son Richard operated it until his death in 1999. A suspicious fire ended plans in 2003 to turn it into a retro Coney Island, and the building was demolished. (Photograph by John Stilber.)

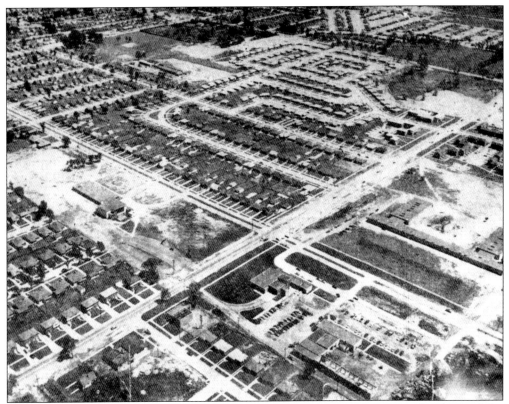

James Shepperd (city councilman 1949–1951) took these aerial views in 1949 and 1955. Coolidge Highway runs from the lower left to upper right in the image below, intersected by Oak Park Boulevard. The same general view shows dramatic growth in the photograph above. The new city hall is in the foreground. In April 1948, city leaders and employees bought their own lumber and bricks. They hired carpenters and bricklayers to do the labor, while the city grader and the department of public works (DPW) laid the foundation. George Bery, an architect and Oak Park resident, guided the project. Also seen in the photograph above are Oak Park High School on the right and Our Lady of Fatima Church on the left.

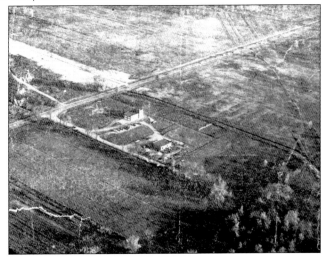

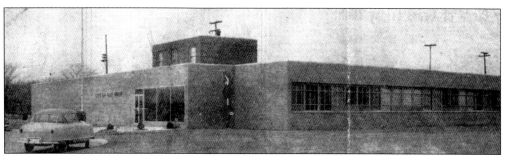

This new structure (above) is a two-story building, housing the police, fire offices, and fire hall downstairs. The city offices occupied the second floor. The DPW offices, partitioned off the south end of the building, were also used for council meetings. When the audience overflowed, fire engines were removed from the fire hall, and tables and chairs were brought in to accommodate the crowd. On November 8, 1948, the move was made to the new city hall. On December 3, 1948, the old building burned to the ground in a fire believed to have been set by young boys. Many of the city records had not yet been removed from the attic and were destroyed in the blaze. The new building was dedicated on November 12, 1952, with state officials, local mayors, and US congressman Dondero as guest speakers.

PROGRAM

DEDICATION CEREMONY

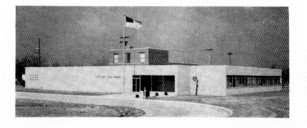

ADMINISTRATIVE BUILDING

13600 OAK PARK BLVD.

OAK PARK 37, MICH.

NOVEMBER 12, 1952

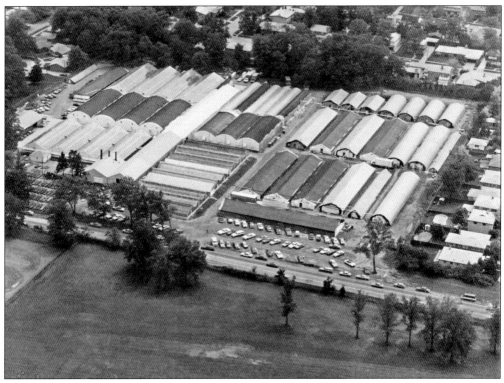

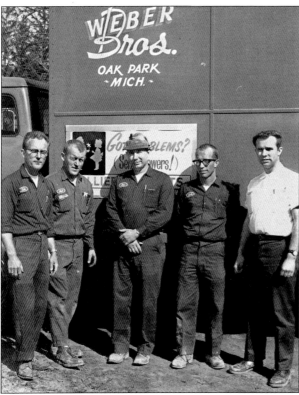

Weber Brothers Greenhouse was established in 1911 when John and Sophia Weber purchased 75 acres on Ten Mile Road between Rosewood Street and Scotia Road. Their five children expanded the business from the 1920s through the 1950s. At that time, the third generation of brothers and cousins took over the operations of the greenhouse. Pictured (at left) from left to right, they are Ted, Bob, Bud, Dick, and Don. Under their leadership, the business enjoyed continued growth through the 1970s. Unfortunately, the business was in the path of I-696, and the state wanted the entire 11-acre site, though only about 2 acres would be used for the I-696 right-of-way. In the mid-1980s, a judge ordered the state to take the entire parcel, forcing the business to close. The state sold the remaining acreage to a builder who developed condominiums. (Courtesy of Don and Mark Weber.)

More federal spending: New deal or raw deal?

History has a lesson for those who want to pump up government spending to "stimulate" the economy and create jobs: During the Great Depression, President Franklin D. Roosevelt's New Deal programs never drove unemployment lower than 20 percent. The jobless rate actually climbed during the second phase. The onset of World War II, not government spending, prompted America's economic recovery.

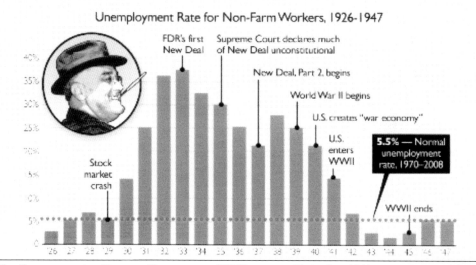

Unemployment Rate for Non-Farm Workers, 1926-1947

FDR's first New Deal

Supreme Court declares much of New Deal unconstitutional

New Deal, Part 2, begins

World War II begins

U.S. creates "war economy"

U.S. enters WWII

Stock market crash

5.5% — Normal unemployment rate, 1970–2008

WWII ends

The Reconstruction Finance Corporation (RFC) was established in 1932 to restore confidence in the banking system. It was expanded by President Roosevelt in 1933 to assist with housing. Between 1937 and 1939, Oak Park was desperately trying to bring new homes to the city while attempting to save others from foreclosure. The commissioners requested loans from the RFC but failed in the attempt. President Garrett, reelected in 1937, took their appeal to the White House and the RFC. He obtained RFC loans for housing as well as $61,930 from the Works Progress Administration (WPA) to repair the streets. The village raised an additional $6,000.

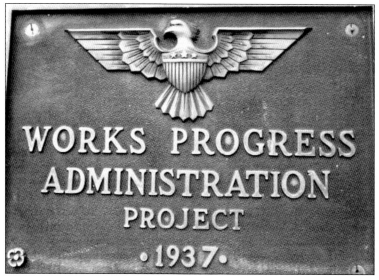

WORKS PROGRESS ADMINISTRATION PROJECT ·1937·

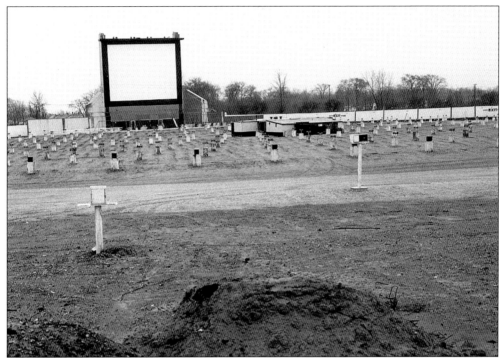

In 1941, work began on the drive-in theater on Eight Mile Road between Coolidge Highway and Greenfield Road near the armory. It was known as the West Side Drive-In and the 8-Mile Drive-In. It had a capacity of 700 cars. Some residents remember hiding in the trunk of a friend's car and climbing out once inside, while others remember sneaking through the fence in the back. Many people have great memories of the fireworks shows and the concession stand. A playground was in front of the movie screen. The drive-in closed in 1984.

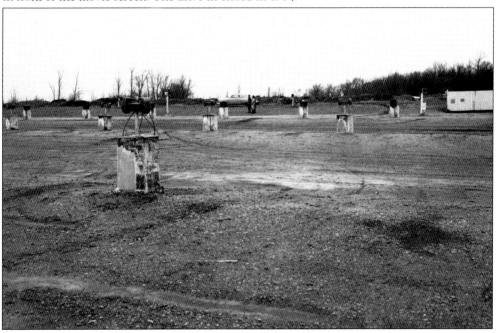

Despite a traffic signal at Ten Mile and Greenfield Roads, little traffic, and little development, accidents still occurred.

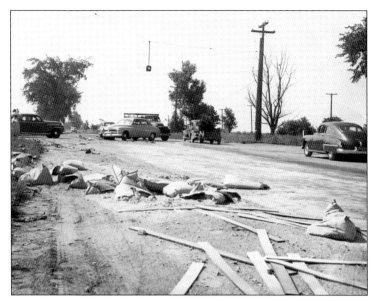

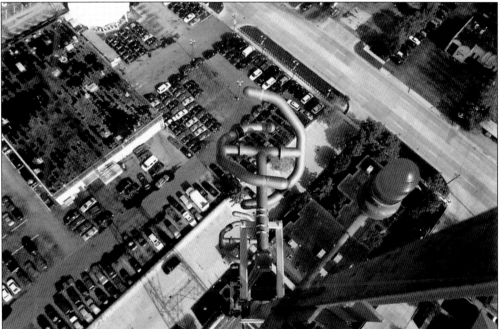

On September 22, 1947, the southeast corner of Ten Mile and Greenfield Roads was rezoned to accommodate an FM radio station studio and transmitter for Lincoln Broadcasting Company and founder and owner Harold I. Tanner. This view is from the top of the tower built for the station. WLDM began as a classical music station. From 1948 until 1978, it evolved from classical to popular music, becoming Detroit's most successful "beautiful music" station. Transmitting in stereo, WLDM pioneered, influenced, and shaped the development and growth of FM broadcasting across the country. WLDM-FM changed its call letters to WCZY-FM ("Cozy FM") in 1976 after being sold to Combined Communications. WCZY-FM became the number-one station in Detroit's age 25 to 54 demographic. In 1981, Gannett Broadcasting purchased the station and changed the format to adult contemporary music. (Courtesy of Clear Channel Radio.)

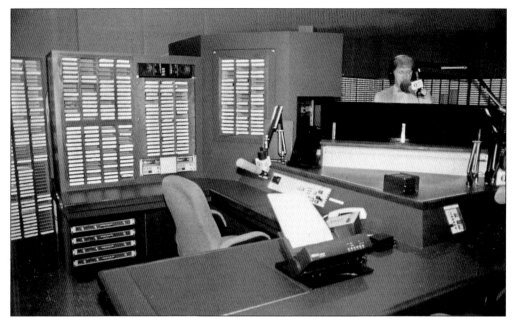

In 1983, Dick Purtan was hired from CKLW to host Cozy FM's morning show. Due to the popularity of Purtan's show, the station posted top-10 ratings through the 1980s. In 1989, the call letters were changed to WKQI, also known as "Q95." Kevin O'Neill was another of the station's popular air personalities. Dick Purtan left in 1996, and the station hired former *Partridge Family* star Danny Bonaduce, who hosted a show until 1998. The station sold the studio and moved operations; the tower remains. (Courtesy of Clear Channel Radio.)

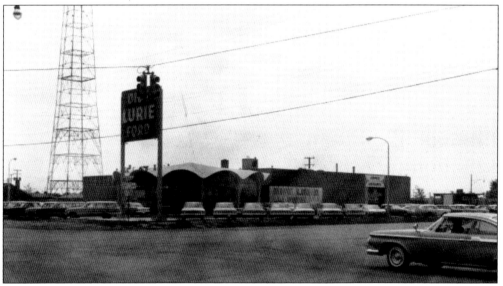

Dick Lurie Ford occupied the southeast corner of Ten Mile & Greenfield. Former resident Nathan Levine designed the distinctive showroom. This intersection was one of the premier entrances to the city. Jacob Bacall bought the property from Ford Motor Land in 2004 and developed it into Greenfield Plaza, a showcase shopping center. Tenants include a national drugstore and specialty shops. Grape Leaves restaurant became the first in the city to offer outdoor seating to its lunch and dinner guests.

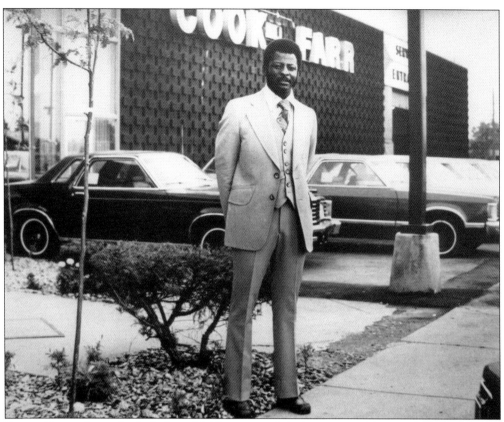

Former Detroit Lions football player Mel Farr entered the business world in 1975. He and partner John Cook opened the Cook Farr Ford Dealership in Oak Park at Ten Mile and Greenfield Roads. In 1978, Farr bought out his partner and formed Mel Farr Ford. In the early 1980s, he advertised heavily on television. For many years, he appeared in commercials flying through the sky wearing a red superhero cape. He was dubbed "your superstar dealer" and earned pop-star status in the Detroit area. In the late 1990s, Mel Farr Auto Group became the number-one African American–owned business in Michigan. In 2002, his franchises were sold, and the dealership subsequently closed. (Courtesy of Mel Farr.)

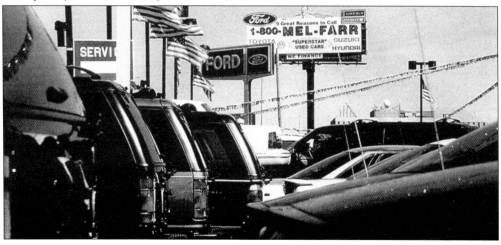

Jefferson School in Ferndale is pictured here in 1954. There are three school districts in Oak Park: the Ferndale District is east of Scotia Road (not including Palmer Woods Manor or Pine Village); the Berkley District is north of Ten Mile Road; and the Oak Park District is comprised of the rest of the city, the charter township of Royal Oak, and the eastern edge of the city of Southfield. In 1949, the Thoroughbred Turf Club wanted to build a racetrack near Jefferson School. Due to protests from the residents and the Ferndale Board of Education, the track was not built. The building is no longer used.

Mayor, council, and staff are pictured during a discussion around 1945. Seated from left to right are Ernest Neuman, Jim Fisher, Harry Cousins, John Molloy, unidentified, Fred Yehle, Paul Commerford, and unidentified; the two men standing on the left are unidentified. (Courtesy of the Molloy family.)

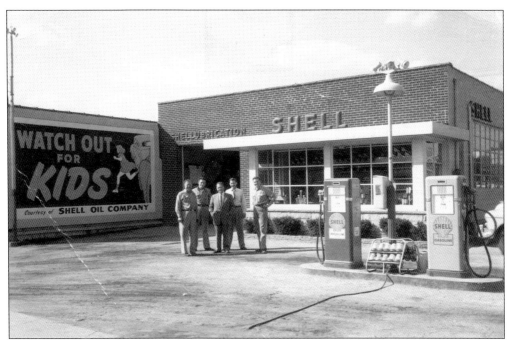

In 1948, Al Hansen opened Hansen's Auto Service Center at the corner of Nine Mile Road and Forest Street. Al's son Jim began working there while still a student at Jefferson Elementary. Except for his service in the Korean War in the early 1950s, Jim has been a part of the service center for all these years and continues to run the highly respected establishment. Initially, they pumped Fleetwing fuel, but when that company moved out of state, Hansen's became a Shell station. They are also an authorized Goodyear Tire dealer. Jim recalled playing trumpet in the Jefferson School band. He performed taps at the first Veteran's Day observance at the first city hall on Nine Mile Road. Jim was honored by the city and served as honorary grand marshal at the city's Independence Day parade. Below, Jim and his nephew Jerry show off his new Jeep. (Courtesy of Jim Hansen.)

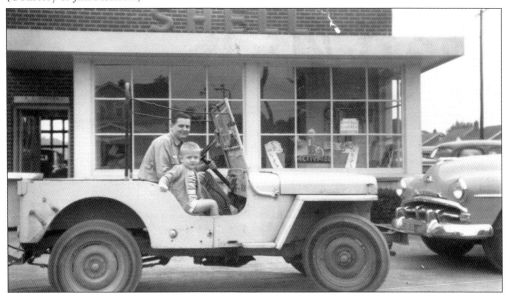

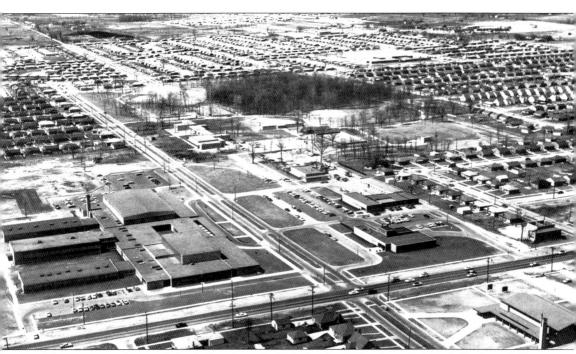

This is an aerial view of city hall and city facilities in the 1950s along Oak Park Boulevard. The municipal complex on the right includes city hall, court, and public safety buildings. The general services/water building was demolished in 2011 to make room for the new city hall. Adjacent to it is the Parks and Forestry Building, which was torn down in the 1990s. The library and community center are next. The outdoor ice arena and newly built swimming pool are behind the library. Oak Park High School is on the left. Note the absence of the football field and track. Our Lady of Fatima Church is on the right, prior to its expansion. The city park is known as Major Park. The two ball fields, CP1 and CP2 (City Park 1 and 2), were just taking shape. The tennis courts are next to the pool. At the western edge of the park is the formation of "The Hill."

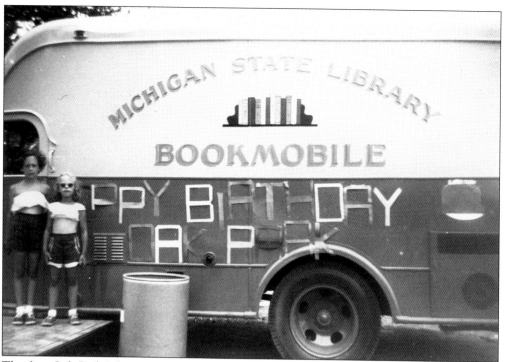

The first Oak Park Library is pictured here in 1955. This bookmobile was a primary source of reading materials for the residents in the library's early years.

Leo T. Dinnan (right) was appointed the city's first librarian, followed by John Oliver and Larry Wember. Wember was succeeded by John Martin in June 1990. When John took over, there were no public computer terminals, and music was played on vinyl LPs.

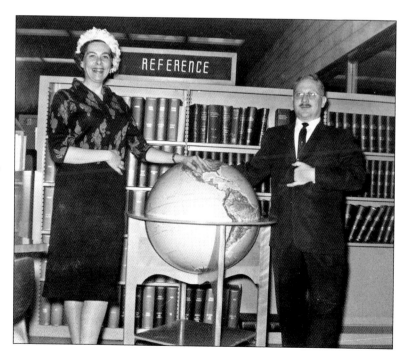

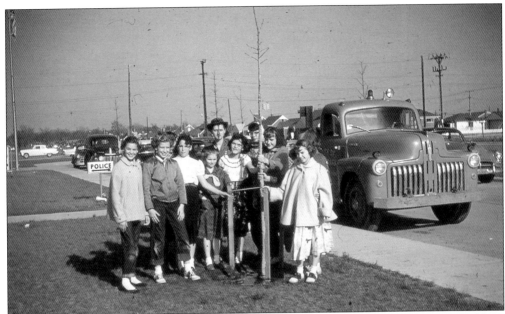

The photograph above shows a tree-planting ceremony in 1953 in front of the public safety building. The image below is of a women's club planting a tree in 1954 to the east of city hall. A group of citizens also planted a tree in front of city hall to exemplify the growth and spirit of unity in the community. Oak Park has been recognized as a "Tree City, USA" by the National Arbor Day Foundation for 28 years. The city also received the prestigious Growth Award in recognition of its tree-planting and maintenance programs. It also recognized the importance of education and the involvement of residents in these annual events.

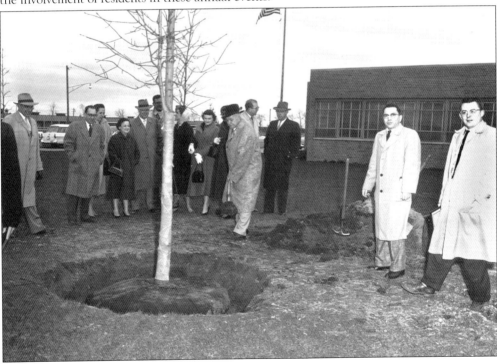

In the early 1950s, Field Building Company announced the development of Ridgewood Estates near the southeast corner of Nine Mile Road and Coolidge Highway. The plan for this 165-acre residential community of 620 homes included paved streets, new sewers, Detroit water, and low taxes. It was only a mile and a half from J.L. Hudson's new Northland Shopping Center. Lessenger Elementary School and Park were future additions to this area.

This is a 1956 view of the new homes and sign at Greenfield Road and Rosemary Boulevard promoting Reddy Wired Homes. Developed by Samuel Wolok and Son, this subdivision encouraged home buyers to take note, as the billboard states, of the "full housepower, built-in electric range, electric dryer outlet and to live better . . . electrically," with appliances by General Electric and in cooperation with the Detroit Edison Co.

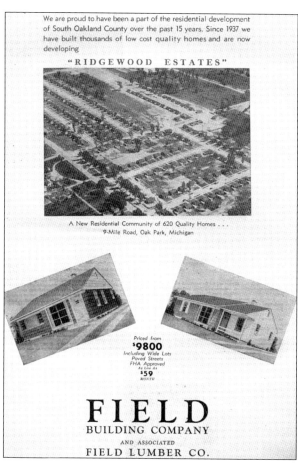

We are proud to have been a part of the residential development of South Oakland County over the past 15 years. Since 1937 we have built thousands of low cost quality homes and are now developing

"RIDGEWOOD ESTATES"

A New Residential Community of 620 Quality Homes . . .
9-Mile Road, Oak Park, Michigan

Priced from
$9800
Including Wide Lots
Paved Streets
FHA Approved
As Low As
$59
MONTH

FIELD
BUILDING COMPANY
AND ASSOCIATED
FIELD LUMBER CO.

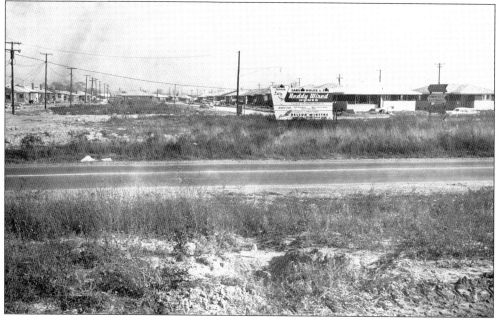

NOW OPEN!

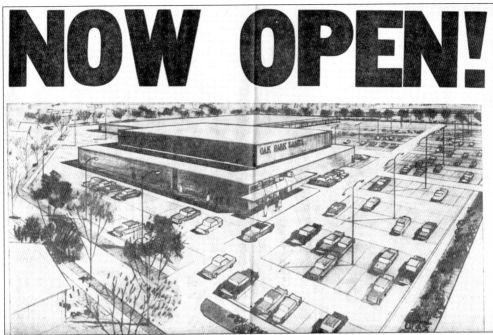

Oak Park Lanes opened in June 1958 on Coolidge Highway just north of Nine Mile Road. Oak Parker Norman Rubin spent $750,000 to make it a bowling "showplace." The 32 automatic Brunswick lanes were billed as the "most beautiful equipment available." The air-conditioned building was decorated with pine and maple paneling and modern furnishings. There was a glassed-in playroom with an attendant so mothers could watch their children while bowling. In the evenings, the room was used for banquets and dinners. There was also a snack shop and sports store.

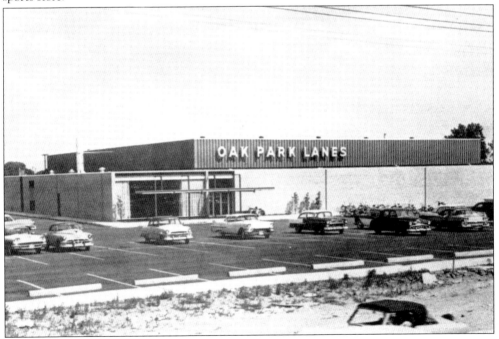

Mayor Richard Marshall is seen inaugurating the lanes by throwing out the first ball with Norman Rubin, Oak Park resident and owner of the bowling alley, admiring his form. Richard Fishman recounted bowling a 300 game, with proprietor Eli Rose watching. Hall of Famer and Oak Park resident Ed Lubanski also frequented the lanes. After bowling, it was common to get a burger at nearby Nelson's, which later became Peppy's.

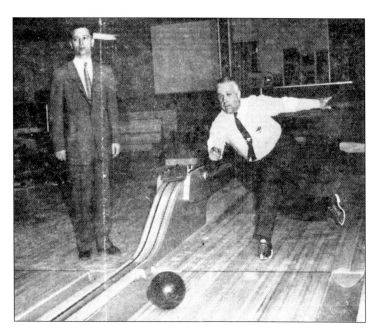

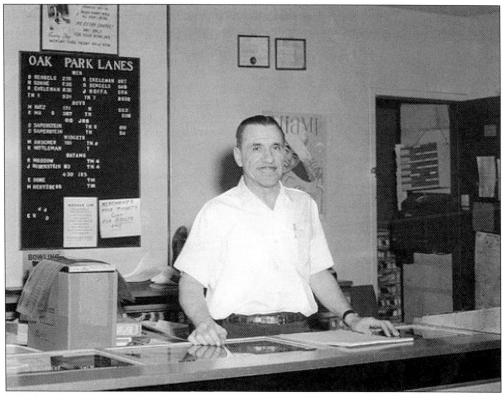

The front counter was the place to rent shoes and lanes. High scores were posted on the back wall.

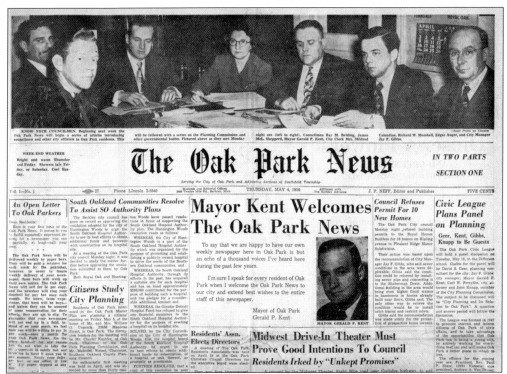

On May 4, 1950, the first edition of the *Oak Park News* cost 5¢. Mayor Gerald P. Kent welcomed the newspaper and extended best wishes to the staff. This photograph shows the mayor, council, and other city officials. The *Oak Park News* would have several ventures with several different publishers, including J.P. Neff, I.S. Nathanson, and David H. Shepherd.

In 1952, parks and forestry superintendent George Hamilton (pictured) imagined a hill at the edge of the park. Residents knew of the area and called the unsightly mound of broken concrete and debris Hamilton's Folly. Hamilton convinced contractors to haul truckloads of dirt from basement excavations and the city's underground water reservoir to the site. His dream became known as Hamilton Hill; residents just call it Oak Park Hill. When not sledding, kids would balance on the logs that were placed on the hill or ride down the hill on a bicycle.

Hamilton Hill was the subject of a first-grade book, *The Hill That Grew*, by Esther Meeks of Chicago. In the photograph below, Steve Knowles holds an autographed copy of the book that he received from his father, Virgil Knowles, the Oak Park city manager. (Courtesy of Steve Knowles.)

43

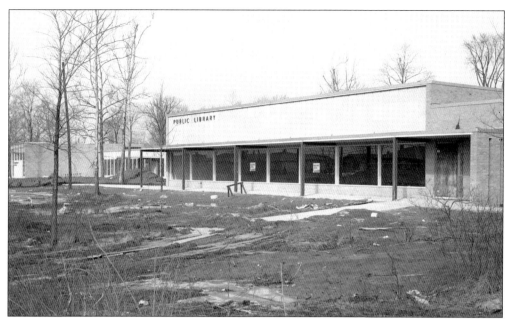

In 1957, construction of the community center/library building was underway. The buildings opened the following year. Shown here are the buildings before landscaping was added. A new wing was built 18 years later and opened in 1976, which runs west from the central entrance of the recreation department and includes the senior center. A major renovation was in progress in 2011.

This photograph shows the city clerk's office in 1956. The switchboard operator connected all calls coming into city offices. Upon entering city hall, this is the first department that people would see. The city clerk is the official keeper of the records of the community, takes minutes of the city council meetings, and handles all elections.

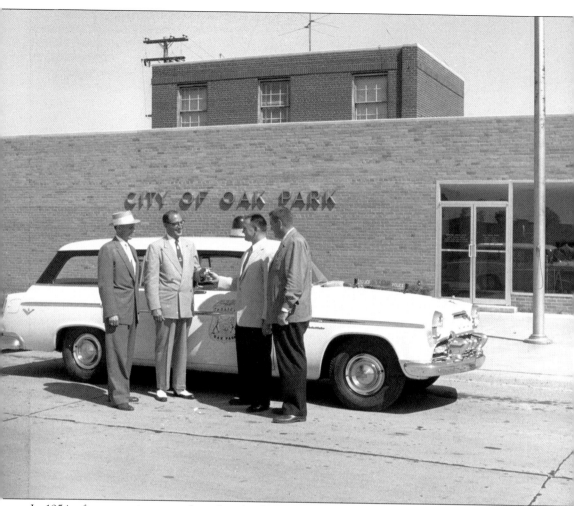

In 1954, after extensive research and study, the city council unanimously adopted an ordinance abolishing separate police and fire departments and establishing a department of public safety. A nationwide search to find a public safety director generated 62 applications. After a thorough process, including written and oral examinations, Glenford S. Leonard was selected. As head of the Escanaba Public Safety Department, he was regarded as an expert on combined police/fire departments. The departments were integrated and cross-trained. Policemen were trained for firefighting duties, including driving the fire trucks and handling all equipment. Firefighters received training in investigation, rules of evidence, criminal law, and city ordinances. By the end of the 1954–1955 fiscal year, the department was operating as a totally integrated police and fire system. In the photograph, public safety director Leonard, second from right, takes delivery of the new public safety car with city manager Harold Schone, on the far right.

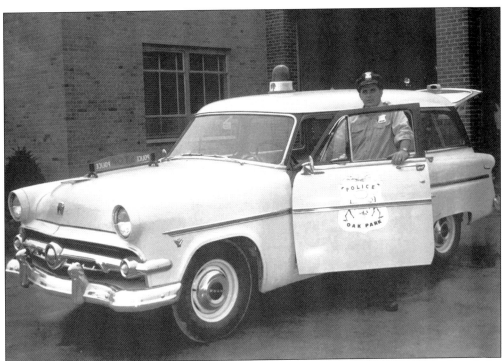

An Oak Park police car is pictured in 1957. Note the insignia says only "Police," even though the police and fire departments had become a combined public safety department.

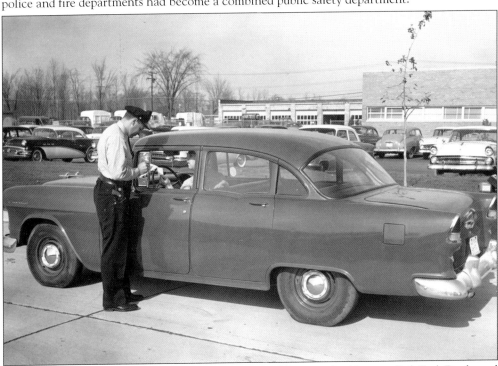

An officer is issuing a violation in front of the General Services Building on Oak Park Boulevard in the 1950s.

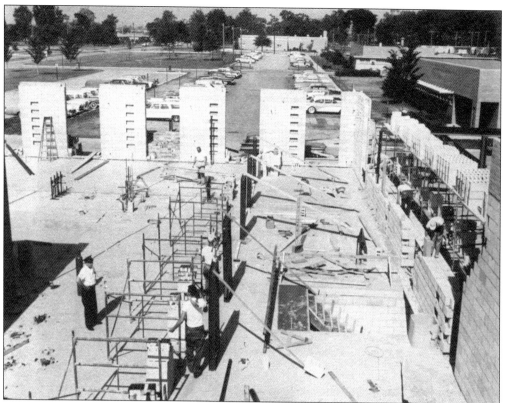

The new Public Safety Building, constructed in 1959–1960, featured 18,000 square feet. The facility provided a modern lab, improved security with electrically controlled doors, and a 50-foot, indoor range with pneumatic target controls. Michigan State University senior students were included in field training. Other communities observed operations in Oak Park. The General Services Building is to the right in the foreground, with the Parks and Forestry Building next, and the library in the background.

City manager Virgil Knowles (right) and Mayor R.J. Alexander inspect the progress of the new public safety addition to city hall; the high school is in the background. City hall and public safety buildings were constructed at different times, starting in the early 1950s. Additions were made on all sides of the original building, extending the east walls, adding a section to the north, and increasing the size of the fire hall.

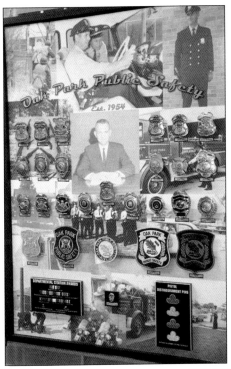

This case of badges and pins is a tribute to director Glen Leonard and the men and women of the department. Included are three main patches used by the officers. The original light blue patch on the left is from 1954 to 1972. The standard Michigan seal, in dark blue and gold trim, is from 1972 to 1992. The current patch with the city seal is second from right. On the far right is a subdued special-response team patch. (Author's collection.)

In the early years, the department had not issued standardized weapons and holsters. Here, two officers radio in to dispatch.

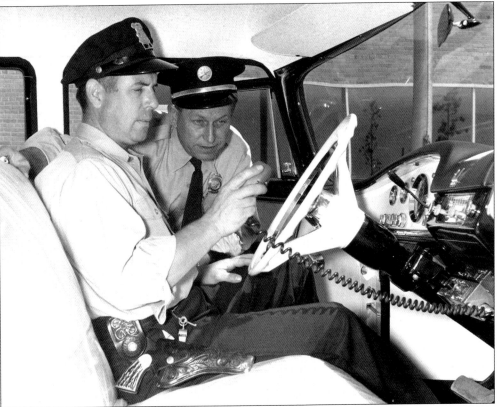

Three

BUSINESS COMMUNITY AND ADVERTISEMENTS

As Oak Park grew as a city in 1945, so too did shopping centers and strip malls. There has never been a central business district or downtown; the intersection of Nine Mile Road and Coolidge Highway was the closest thing to it. A variety of smaller strip malls can be found throughout the city, at Lincoln Avenue and Coolidge Highway, Scotia and Ten Mile Roads, and on Nine Mile Road. The Green-8 Shopping Center, which had Topps department store, Savon, Fava Music, and Studio 8 Theatre, was on Greenfield Road north of Eight Mile Road. The corner of Ten Mile Road and Coolidge Highway was the site of the Dexter Davison Shopping Center. New owners of the center tore down a section, bought a few homes along Ten Mile Road, and constructed a new, longer center. Dexter Davison Market would become A&P/Farmer Jack, although the supermarket chain later closed this store. Many of the business owners sponsored events and scholarships and gave money to support city projects, recreation programs, and students.

The late 1950s and 1960s brought many new businesses and the need to advertise in newspapers. The following pages contain just some of these advertisements. They appeared in the *Daily Tribune*, *Oak Park News*, *Town Crier*, and others. Shops and restaurants, such as Small Fry Fashion, Stafford's, Lorber Bar-B-Q & Pizza, Miami Bakery, Mumford Sports Center, Rudi's Barber Shop, Irv Ashin Jeweler, Detroit Bagel, Fred's Party Store, Harvard Shop, Liberman's, Daring Drugs, Benny's Deli, and even the Tennis Bubble in the park were a part of the fabric of Oak Park.

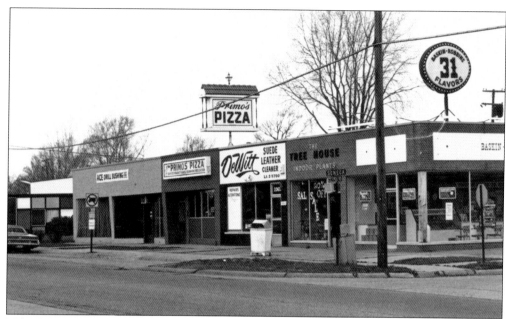

Mike Soave opened the original Primo's Pizza in 1968 on Nine Mile Road. A fire in 1984 prompted the move east to its current location. Mike and Kim Soave, honorary parade grand marshals, have been very generous to the community, sponsoring city and police events, youth baseball teams, and regularly providing pizzas for the schools and the city. Their pizza has been voted "No. 1 Best Pizza."

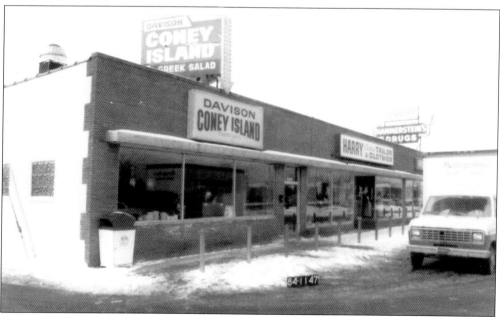

Davison Coney Island has been a local institution since 1971, when the late Steve Lampos moved it from Detroit with his son Phil. Sam Bazzi has worked there since 1989. He and his wife, Christa Larson-Bazzi, purchased Davison Coney Island in 2008. They actively support the community and were named honorary grand marshals of the Independence Day parade. Their award-winning chili and soups draw both current and former Oak Parkers.

Ernie Hassan is a legend. Ernie's Market has been located on Capital Street and Republic Avenue since his father opened the store in 1950. Amidst the old store shelves and memorabilia, Ernie adds a little love and performance to every sandwich. Ernie's has been voted "No. 1 Best Sandwich Shop" for years. (Courtesy of Ernie Hassan.)

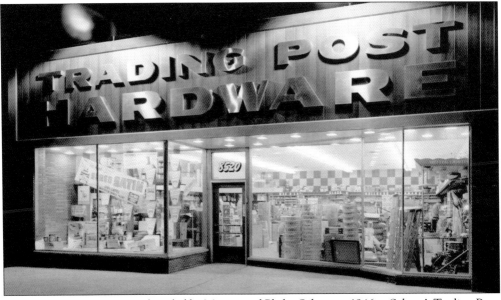

Scheer's Ace Hardware was founded by Martin and Philip Scheer in 1946 as Scheer's Trading Post. They joined Ace in 1958. The current location on Nine Mile Road opened in 1968. In 1970, they purchased the lot next door, creating a new parking lot and entrance. In 1978, they bought the attached building owned by Estes Electronics. Marty's daughter Carol Steffes and Paul Krupkin are the current owners. Phil's son Howard retired in 2009. (Courtesy of the Scheer family.)

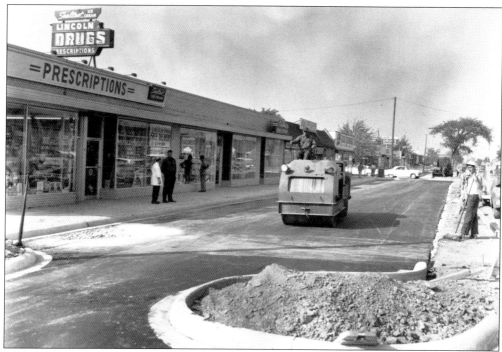

Julius Passerman (above, in the white coat) oversees the newly paved parking lot in front of Lincoln Drugs. The drugstore, located on Coolidge Highway and Lincoln Avenue, opened in 1955. Son Alan (below, next to his father, Julius) took over the pharmacy in the mid-1970s, following the death of Julius. Alan's mother, Faye, and sons Brian, Mark, and Danny all worked there. Sam Loussia bought the drugstore in 1988 with Alan continuing to run the pharmacy. Sam's sons Joseph and Anthony also work at the store, and everyone is greeted by name. Together, they all continue Lincoln Drugs' commitment to the community. The phone number, LI-37847, stands for Lincoln Drugs on the phone dial, as the letters "LI" represented the Lincoln exchange in the 1950s. (Courtesy of Alan Passerman.)

North End Collision has been in Oak Park since 1967. Owner and president Ernie M. Solomon has expanded the business from collision repair and bodywork to include computerized testing, brake work, routine maintenance, and leasing. The shop suffered a major fire in 2009 that destroyed the building. Solomon preserved his good reputation by using the opportunity to build a truly "green" business. (Courtesy of Ernie Solomon.)

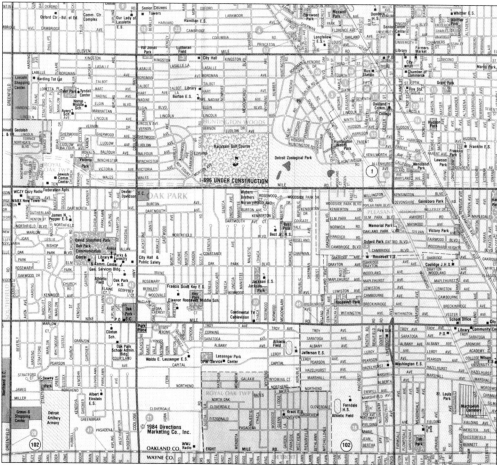

During the 1980s, Oak Park and Royal Oak shared a joint chamber of commerce and produced this 1984 map. The shaded area along Greenfield Road from Ten Mile Road to Lincoln was Royal Oak Township. Dashed lines along the center indicate where I-696 was under construction. Weber Brothers Nursery appears below the line. WCZY Radio was located at Ten Mile Road and Greenfield Road. Schools and shopping centers are noted, including Green-8 Shopping Center. The Detroit Artillery Armory can be seen as well.

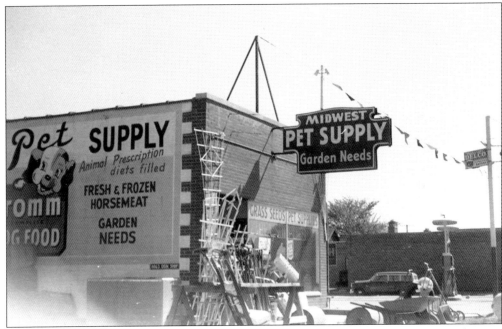

These photographs were taken by code enforcement to show the signs that were nonconforming at the time. Many businesses had a sign on top of the building, and each business wanted to make theirs bigger and taller than the one next door. This pet supply store was next door to Hansen's Auto on Nine Mile Road.

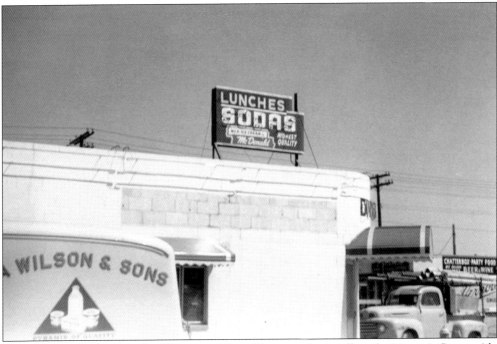

This photograph shows an Ira Wilson and Sons Dairy truck as well as the Vernor's Ginger Ale truck in the background making a delivery at the Parkwoods Diner on Coolidge Highway at Eleven Mile Road.

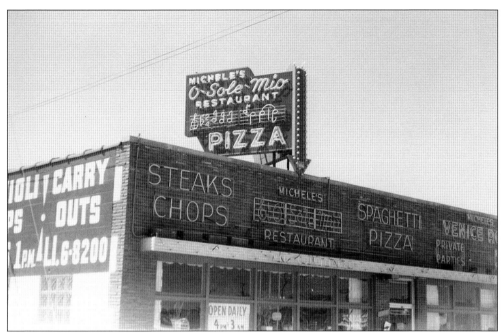

Michele's O-Sole-Mio Restaurant occupied the location currently used by Davison Coney Island at Nine Mile Road and Coolidge Highway.

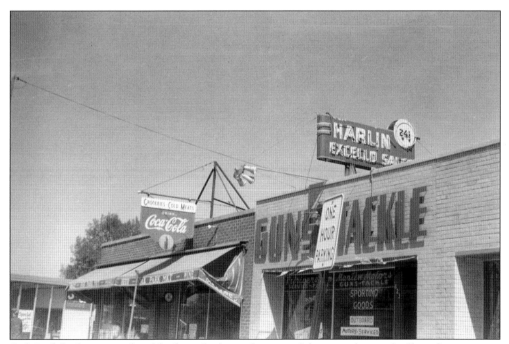

Oak Park had a gun and tackle shop. In the early years of the township and village, hunting was very popular. As the population grew, laws made it illegal to fire weapons within the borders of the city.

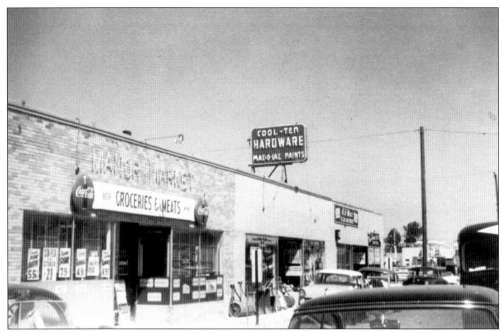

The Cool-Ten Hardware Store and Manor Market were located at the southwest corner of Ten Mile Road and Coolidge Highway. The cleaners on the right side of the photograph would end up moving to the left end of the strip. Gas stations would be located on the northwest and southwest side of Ten Mile Road.

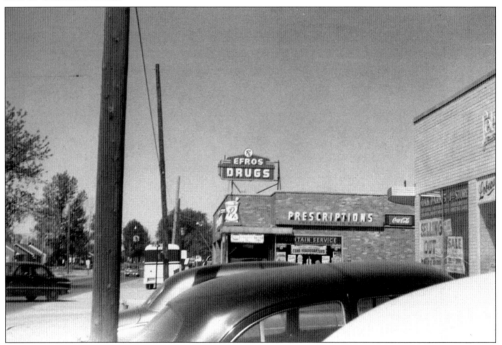

Efros Drugs at Nine Mile Road and Geneva Street offered prescriptions and fountain service. The Efros family has been a longtime fixture in Oak Park. They moved their business to the city of Southfield.

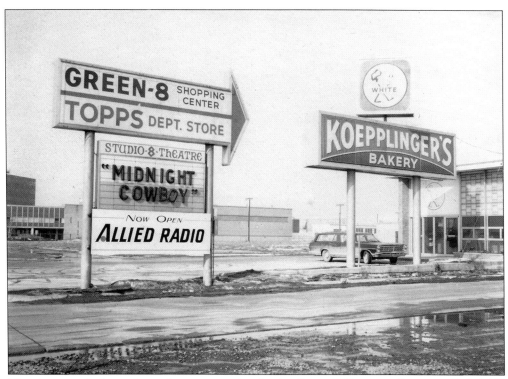

The photograph above shows the entrance sign for the Green-8 Shopping Center on Eight Mile Road east of Greenfield Road, between Koepplinger's Bakery and the armory. Topps department store (below) anchored the east end next to Savon (A&P) supermarket. Along the north side of the center, there were "23 stores to serve you." They included the Good Housekeeping Shops, Bottle 'N Gift, Buy-Rite, Fava Music, optometrist Dr. Golden, Greenfield's Restaurant (later Eddie Bauer), Irv Grumet Men's Wear, Marty's Delicatessen, Shifrin-Willen's, Stroh's Ice Cream, and Studio 8 theater. *Midnight Cowboy*, released in 1969, is advertised on the marquee. In later years, Handy Andy and Office Depot were tenants. Jack Macauley, owner of Macauley's office supply, supported the schools and city and served as a grand marshal of the city's parade.

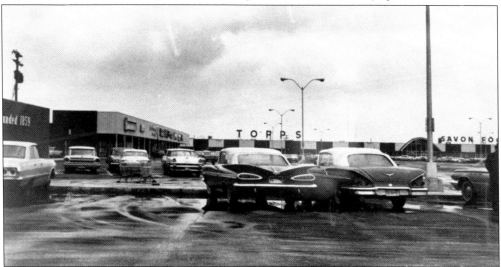

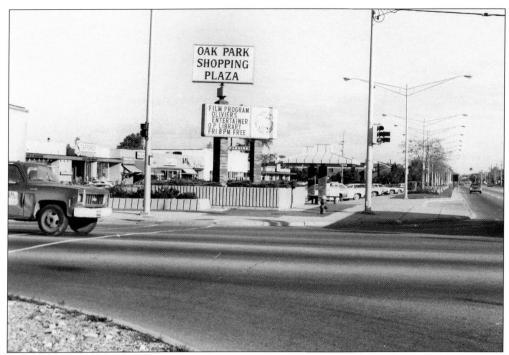

This original marquee was the focal point on the northwest corner of Nine Mile Road and Coolidge Highway; however, it could only display one message at a time. City workers manually changed the letters to change the message. Thanks to donations from National City Bank (now PNC) and Orchard, Hiltz, and McCliment, a new electronic sign (see page 127) was installed, allowing for multiple messages in various colors and fonts.

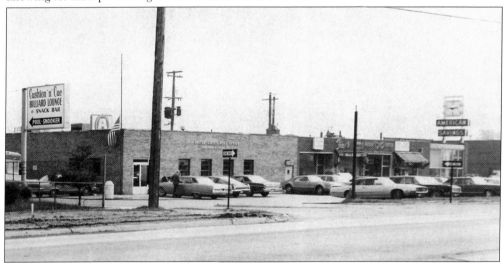

From left to right, the original post office, the office of podiatrist Dr. Smelsey, Rosen Optical, and American Savings Bank appear in this photograph. This drive also led to Cushion "N" Cue, owned by Ray Abrams (who served with distinction as councilman from 1985 to 2002). The city council and planning commission fought to keep a new post office at this same intersection; however, postal officials bought land about 100 yards off Eight Mile Road from Roy "Chief" Church of Church's Lumber Yards.

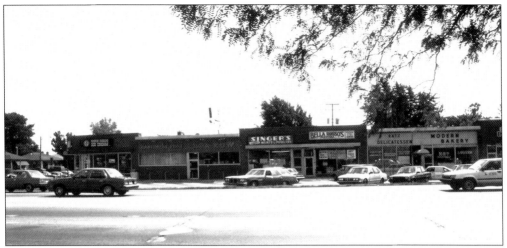

Here are businesses on Nine Mile Road, two blocks west of Coolidge Highway. Hoa-Kow, Katz Delicatessen, and Modern Bakery were popular destinations for Oak Parkers. Hoa-Kow was one of the few restaurants open on Christmas Day, and having a meal there then became a tradition for many families. There was stiff competition between Katz's Deli and Stage Deli, located a block west, for the best corned-beef sandwich and matzo ball soup. Favorite choices at Modern Bakery were seven-layer cake and sprinkle cookies.

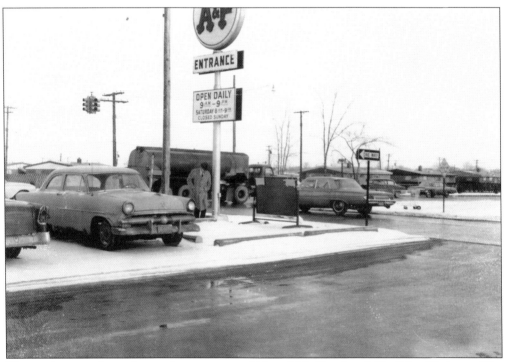

This is the view from the southeast corner of Nine Mile Road and Coolidge Highway. The shopping center was owned by Oscar Genser and had many favorite shops, including Sander's Ice Cream.

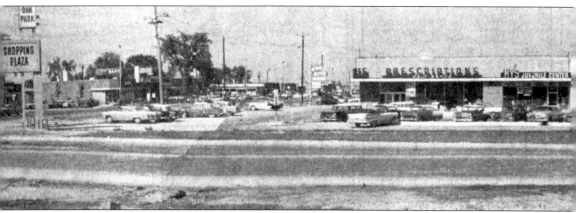

A 1950s newspaper photographer's panoramic view of the Oak Park shopping plaza at Nine Mile Road and Coolidge Highway shows a fine selection of stores.

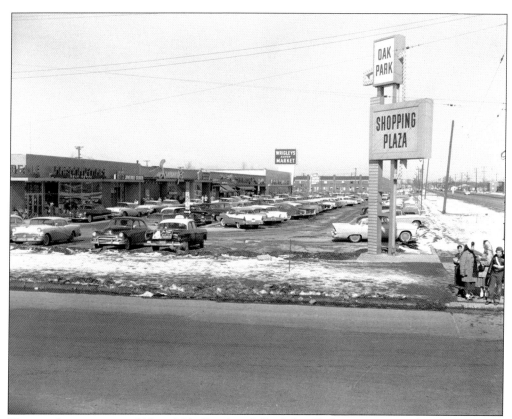

The northwest corner of Nine Mile Road and Coolidge Highway was considered one of the main shopping centers. The center included such names as Wrigleys Supermarket, Jacqueline Shops, Small Fry Fashion, Ben Franklin Five and Dime, Irv Grumet, Miami Bakery, Sammy's and Stafford's Restaurants, Little Professor Book Store, Sentry and Belle drugs, A La Mode, and Pub Ice Cream. (Courtesy of the Walter P. Reuther Library.)

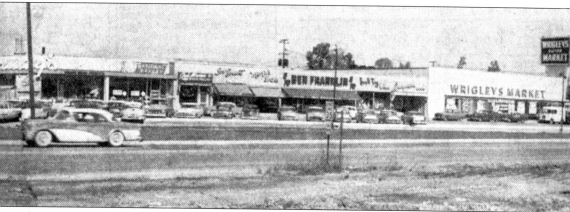

The panoramic shot, taken by R.K. Arnold and published in the *Detroit Times* on May 29, 1957, highlights the dynamic growth of Oak Park, a Model City.

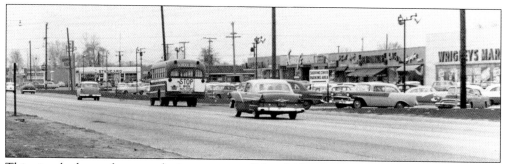

This view looks southwest at the intersection of Nine Mile Road and Coolidge Highway toward the Standard Station from just north of Wrigleys Supermarket.

Here is Coolidge Highway and Kenwood Street looking south toward Nine Mile Road was taken before Oak Park Lanes was built. Despite popular belief, McClain Drive was not named for former Detroit Tigers pitcher Denny McLain.

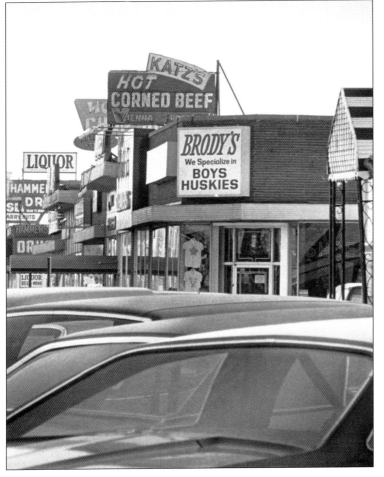

This scene from the parking lot off of Nine Mile Road and Westhampton Street was taken by the building and code enforcement department to illustrate the signage battles. It is an interesting combination of stores, from Brody's and Katz's Deli to Hoa-Kow and Hammerstein Drugs.

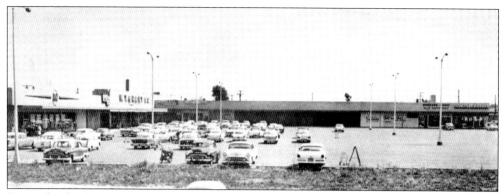

Pictured is the shopping center at the southeast corner of Nine Mile Road and Coolidge Highway, owned by Oscar Genser. This center included A&P supermarket, Sander's Ice Cream, W.T. Grant, Mumford Music, and Schettler's Drugs. Genser served the city with distinction on the planning commission and zoning board. (Courtesy of the late Oscar Genser.)

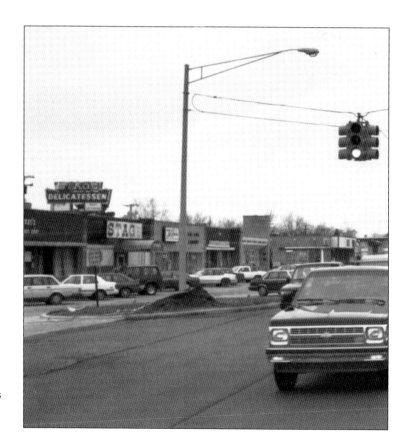

This view looks west down Nine Mile Road from Westhampton Street toward Rudi's Barber Shop and Stage Delicatessen.

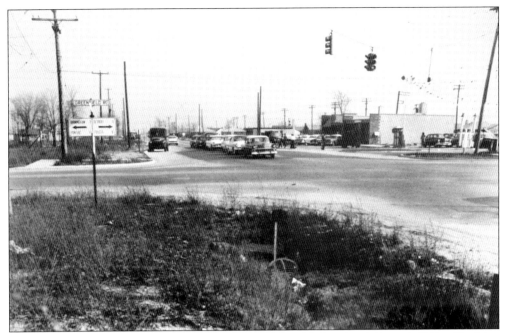

Seen here is the undeveloped northwest corner of Nine Mile Road and Greenfield Road looking east. The sign on the left, marking Greenfield Road, notes that Detroit is 11 miles to the right, Toledo is 61 miles to the right, and Birmingham and Pontiac are 7 miles and 11 miles to the left, respectively.

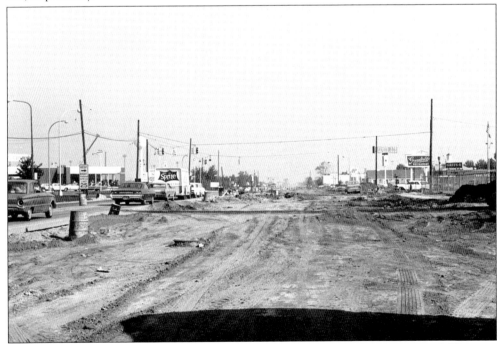

This image shows the Greenfield Road reconstruction looking north. The Green-8 Shopping Center and the sign for Greenfield's Restaurant are visible on the right. The Northland Shopping Center is to the left.

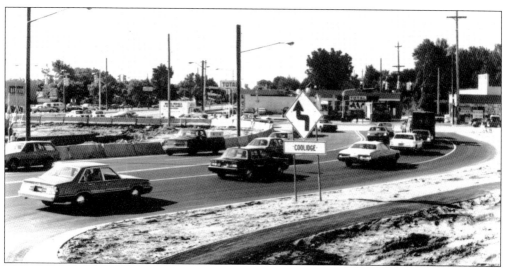

During construction of I-696, a temporary detour was built at the intersection of Ten Mile Road just west of Coolidge Highway. This photograph, facing the southwest corner, shows Livernois Glass and Total gas station. In the distance are the signs for Levin Beauty Supply and Dexter-Davison market.

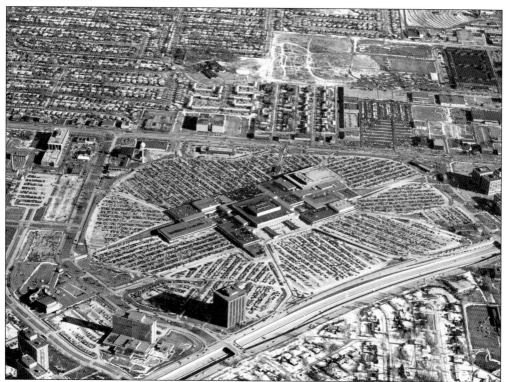

An aerial view from the 1950s looks east over the Northland Shopping Center. Even though the center is in the city of Southfield, it also is a part of the Oak Park School District. Greenfield Road cuts from left to right in the middle of the photograph. Looking toward the upper right, the vast armory property is visible, with the Green-8 Shopping Center just below it. The West Side Drive-In is also located to the upper right of the photograph. (Courtesy of Hank Becker.)

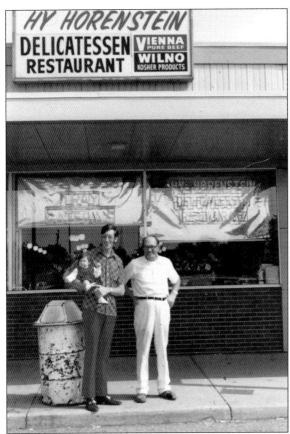

Hy Horenstein's was a popular delicatessen in the Dexter Davison Shopping Center at Ten Mile Road and Coolidge Highway. Seen here are Hy, his son Ray, and Ray's daughter Michelle. (Courtesy of Joe Horenstein.)

Located on Eight Mile Road west of Coolidge Highway, the Oak Park Grill was one of those greasy-spoon restaurants that had a very loyal following.

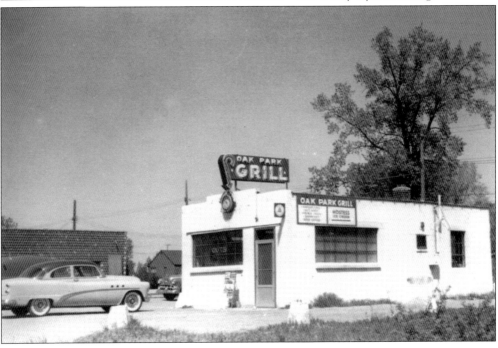

Hansen's Auto Service on Nine Mile Road is seen here in the 1940s when it sold Fleet-Wing gas and long before additional expansion of other businesses along the strip next door. Nine Mile Road was just a single paved lane each way; side streets were still gravel roads. A pet supply store would be built next door years later. (Courtesy of Jim Hansen.)

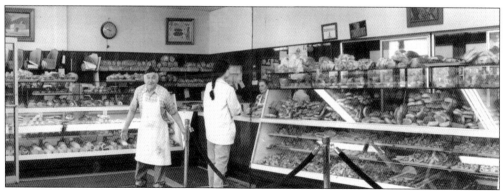

Morris Weiss was the owner of Zeman's Bakery. Weiss, pictured above, left, owned the bakery since the early 1970s. The bakery on Greenfield Road north of Ten Mile Road has always had an Oak Park mailing address despite being located in Royal Oak Township. Following the annexation of this portion of the township by Oak Park, Zeman's became a true Oak Park business. (Courtesy of the Weiss family.)

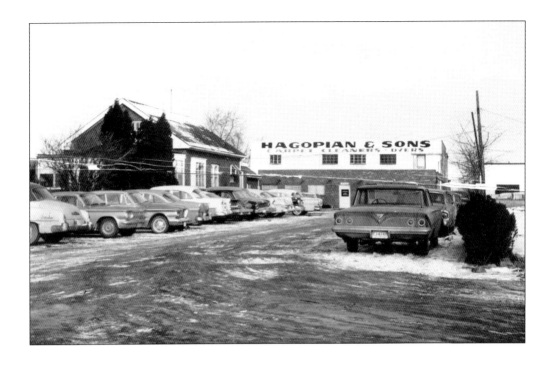

Hagopian Carpet has called Oak Park home since 1948. Harry Hagopian began by making perfume in his basement, which led to creation of LaSalle Chemical Products Company. In 1938, a phone call changed his life. His knowledge of chemicals helped remove ink from a customer's carpet, and he realized the potential of this as a business. He changed the company name to Hagopian and Sons Inc. and moved the business to Oak Park. In the early 1950s, sons Stephen, Edgar, and Arthur and daughter Ilene joined him. Hagopian and Sons became the largest carpet and rug dealer in metropolitan Detroit. The Hagopians have always been generous supporters of Oak Park. Edgar has been honored as grand marshal of the Independence Day parade. (Courtesy of Ken Snow, president of Hagopian.)

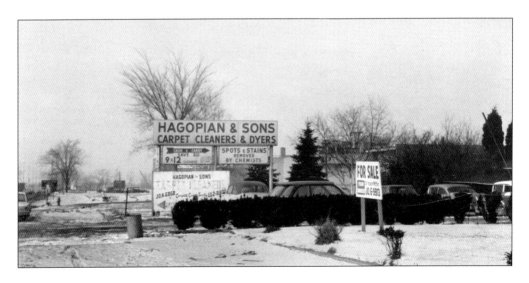

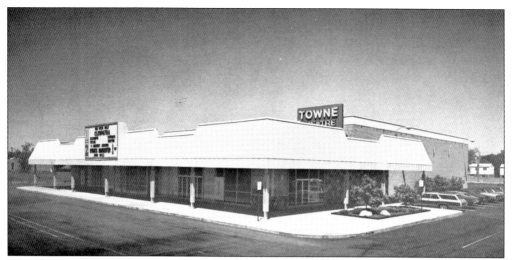

The Towne Theatre No. 1 and No. 2, in the Lincoln Shopping Center, opened in 1967 and closed in 2000. They had a total of 1,400 seats and were managed by Fred Sweet for two decades. An Aldi's market is located in the Towne Theatre space today. To the south, an office building was in the center until it burned in 1988. Kmart opened in 1989 and continues to operate there today. (Courtesy of the Etkin family.)

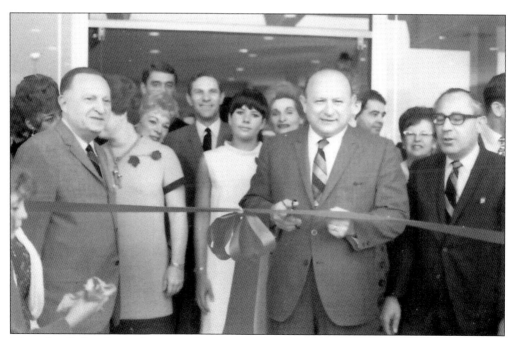

Mayor Joe Forbes (with the scissors) participated in the ribbon-cutting ceremony at the grand opening of the Lincoln Shopping Center. Owner Ben Etkin is on the far right. (Courtesy of the Etkin family.)

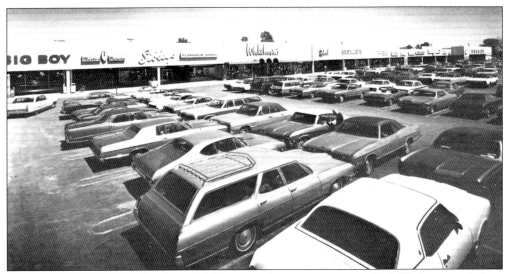

Owned by the Etkin family, the 110,000-square-foot premier center had 32 shops, including Winkelman's, Shifman's, Cunningham's drug store, Big Boy, and many other major names. (Courtesy of the Etkin Family.)

This is the intersection at Ten Mile and Scotia Roads during construction of I-696. The Scotia Stop food store, originally located on the southeast corner, moved to its current location on the southwest corner. Jason Kuza and his family have always been big community supporters and take good care of their loyal customers. Mill Floor Covering, originally home to a Food Giant store, was demolished to make way for additional space at the center and for a clubhouse for the apartments next door.

Davison Coney Island announced the grand opening of the Oak Park location at Nine Mile Road and Coolidge Highway in April 1971. It was not just known for Coneys, as it had "World Famous Sloppy Joes," too.

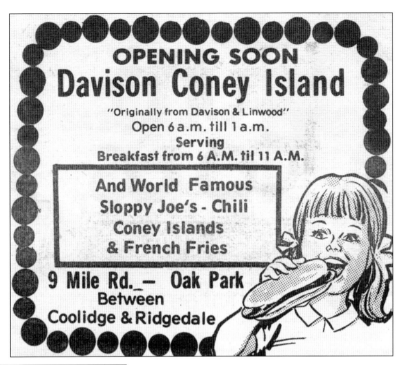

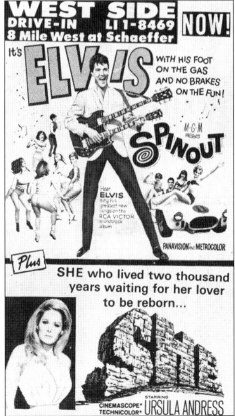

Here is an ad for a double-bill at the West Side Drive-In in 1966. Race-car driver/singer Elvis Presley had his hands full in *Spinout*, with tree women out to snare him; the movie also starred Shelley Fabares. The double-bill also had Ursula Andress in *She*.

This advertisement from the mid-1960s is for Singer's Kosher Meats and Poultry at Nine Mile Road and Ridgedale Street. It was not just a place for those who kept Kosher, as many people were attracted by the high-quality food products that were considered healthier.

The Original Bread Basket Deli opened in November 1977 in the Lincoln Shopping Center. Ron Forman was the founder of the deli. The sandwiches were loaded with meat, and the tradition of giant portions continues today. The BB Special Salad comes with corned beef, turkey, cheese, and a hard-boiled egg. The soup has matzo balls the size of softballs. The Mish Mash soup comes with a little bit of everything.

Jerry Efros' Pharmacy, located at Nine Mile Road and Geneva Street, billed as "Your Fortress of Health," advertised prescriptions professionally perfect and properly priced.

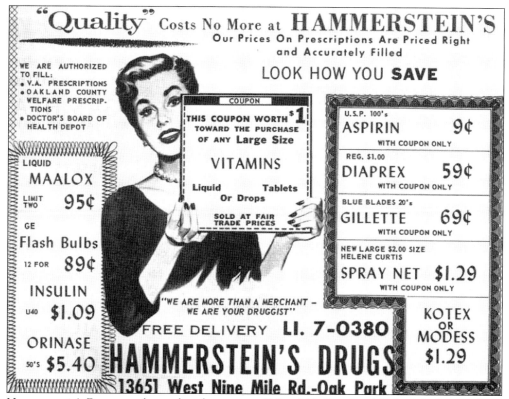

Hammerstein's Drugs was located at the corner of Nine Mile Road and Ridgedale Street, where "Quality Costs No More." Aspirin was just 9¢, and 12 little GE flash bulbs were 89¢.

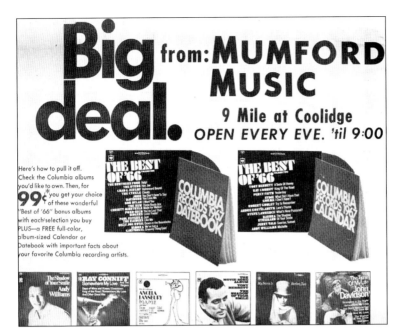

This is a Mumford Music advertisement from December 1966. Located at Nine Mile Road and Coolidge Highway, it featured popular music by artists such as Andy Williams, Jim Nabors, Eydie Gormé, The Byrds, and many more. Those days, customers bought 45s and LPs.

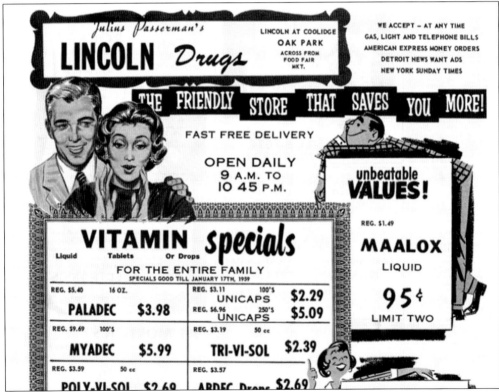

Seen here is a January 1959 advertisement for Julius Passerman's Lincoln Drugs, located on Coolidge Highway and Lincoln Avenue. Julius's son Alan and Sam Loussia continue the tradition of excellent service today.

This is a March 1966 advertisement for Howard Johnson's, also known as "HoJo's." The restaurant, located at 13400 West Eight Mile Road at Coolidge Highway, was famous for its orange roof. Customers went there for the fried clams and pie. Clam chowder specials were three for 99¢. It also offered, for $1.19, an all-you-can-eat fish-fry dinner with coleslaw and french-fries.

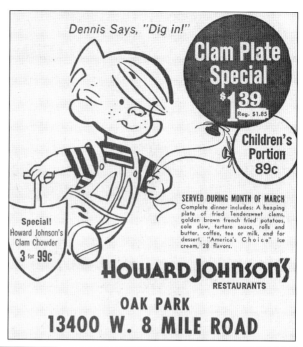

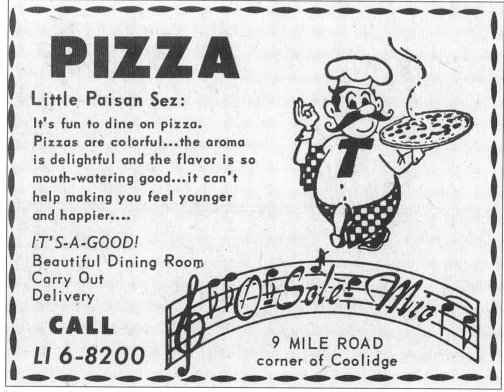

Here is an advertisement for O-Sole-Mio from April 1966. The beautiful dining room created the perfect atmosphere to enjoy a pizza pie with friends and family. It was located at the southwest corner of Nine Mile Road and Coolidge Highway.

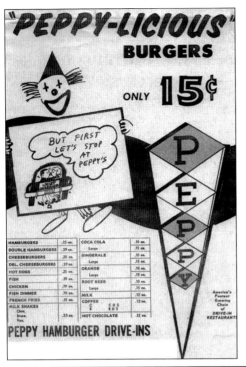

Peppy Hamburger was the place to go before Oak Park had a McDonalds or White Castle. It had 15¢ hamburgers and 25¢ hot dogs, and milk shakes were only 25¢, too. A regular Coca-Cola was just a dime, and a large could be had for just a nickel more. The restaurant had a drive-in, which was unusual for Oak Park. People would often walk over to Peppy's after bowling at Oak Park Lanes.

Primo's opened in 1968 and featured the pizza man making his pies in 15 minutes for pick-up as well as a delivery option. This advertisement is from the time of its 10-year anniversary. Family-owned Primo's No. 1 is still delivering quality food and service to Oak Park and beyond.

Jack Barnes Dance Studio was a popular place to take dance lessons before attending bar and bat mitzvahs and sweet 16 birthdays. This advertisement is from January 1966.

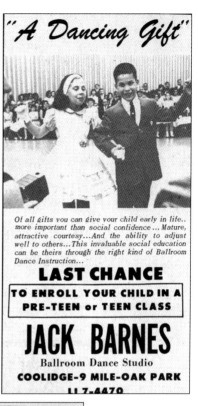

"A Dancing Gift"

Of all gifts you can give your child early in life.. more important than social confidence... Mature, attractive courtesy...And the ability to adjust well to others...This invaluable social education can be theirs through the right kind of Ballroom Dance Instruction...

LAST CHANCE

TO ENROLL YOUR CHILD IN A PRE-TEEN or TEEN CLASS

JACK BARNES
Ballroom Dance Studio
COOLIDGE-9 MILE-OAK PARK
LI 7-4470

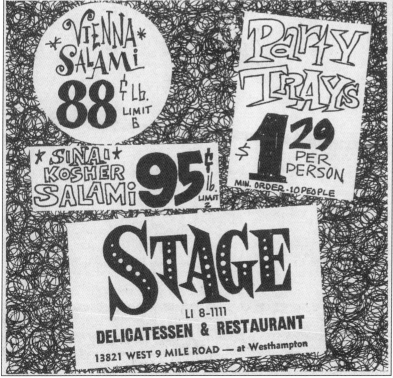

* VIENNA * SALAMI 88¢ lb. LIMIT 6

* SINAI * KOSHER SALAMI 95¢ lb. LIMIT 2

Party Trays $1 29 PER PERSON MIN. ORDER - 10 PEOPLE

STAGE LI 8-1111 DELICATESSEN & RESTAURANT 13821 WEST 9 MILE ROAD — at Westhampton

Jack Goldberg and his family opened Stage Deli on Nine Mile Road, west of Coolidge Highway, in 1962. Sandwiches were named after Broadway and stage favorites. The classic hot corned beef or pastrami on freshly baked rye were packed with meat. The matzo balls in the soup were enormous. Chopped liver or lox on bagels were served in portions big enough to share.

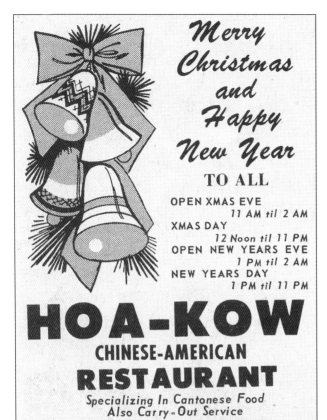

Merry Christmas and Happy New Year

TO ALL

OPEN XMAS EVE
11 AM til 2 AM
XMAS DAY
12 Noon til 11 PM
OPEN NEW YEARS EVE
1 PM til 2 AM
NEW YEARS DAY
1 PM til 11 PM

HOA-KOW

CHINESE-AMERICAN

RESTAURANT

Specializing In Cantonese Food
Also Carry-Out Service

13715 W. 9 MILE

Just W. of Coolidge-OAK PARK

FREE PARKING LI 7-4663

This advertisement for Hoa-Kow from December 1966 notes it is open on Christmas and New Year's Day. The restaurant, owned by the Woo family, was popular with the large Jewish population who loved Chinese food and did not have many choices on Christmas Day. Many families went for Sunday dinner or take-out.

This 1969 advertisement for "All Channel TV" sales and service store, located on Nine Mile Road west of Coolidge Highway, is actually a postcard that was mailed to residents; the postage rate was 2¢. The store advertised "New Admiral TVs" and service on all radios and televisions. Back then, people brought their sets for service and replacing the Sylvania Picture Tubes. Today, people just buy a new television. (Courtesy of the Rosenberg family.)

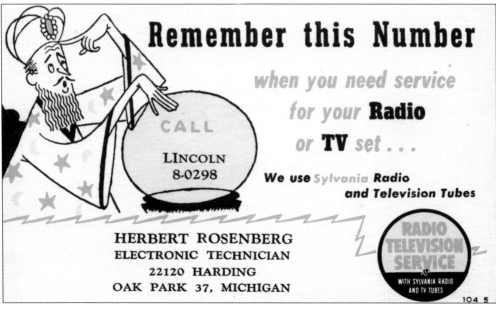

Remember this Number

when you need service
for your **Radio**
or **TV** set . . .

CALL
LIncoln
8-0298

We use Sylvania **Radio
and Television Tubes**

HERBERT ROSENBERG
ELECTRONIC TECHNICIAN
22120 HARDING
OAK PARK 37, MICHIGAN

RADIO TELEVISION SERVICE
WITH SYLVANIA RADIO AND TV TUBES

104 S

Four

SOME OAK PARK PEOPLE

The list of people who have spent even part of their life in Oak Park is long. It includes athletes, entertainers, educators, photographers, doctors, and lawyers. Some have gained a local following, while others have achieved international acclaim in their area of expertise and talent. They may have traveled across the world, but they continue to check in on their former city and its people. Some of them return for high school reunions and programs, while some have returned for the annual parade or to skate on the ice rink. Oak Park has been fortunate to have people who have donated their time in service to the city. The elected officials, employees, and volunteers who have served through the years helped create, review, and expand services and programs. The following pages reflect on just a few of these people.

Byron MacGregor and JoJo Shutty MacGregor hosted the Ethnic Festivals for many years. JoJo grew up in Oak Park and was the first female helicopter news and traffic reporter in North America. Byron, who died in 1995, was the first newsman in Detroit to simultaneously anchor prime-time newscasts on radio (WWJ) and television (WKBD-TV). Byron was best known for his spoken-word recording of a patriotic commentary, "The Americans."

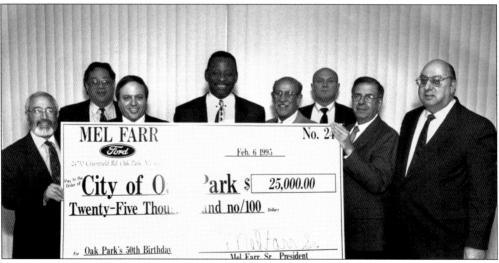

Mel Farr presents a $25,000 check to help the city celebrate its 50th anniversary in 1995. Farr's gift attracted other large donors, and more than $100,000 was raised. As a result, special concerts were held during the year, including a special program for the members of the city's boards and commissions where the Smothers Brothers performed.

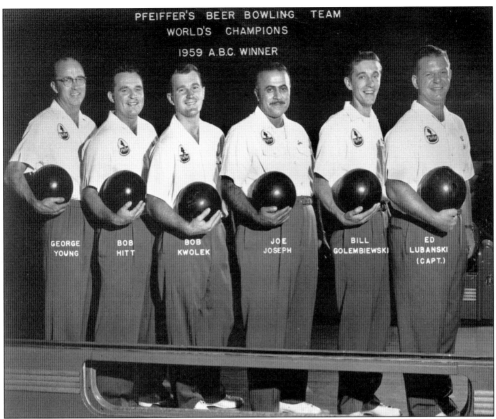

PFEIFFER'S BEER BOWLING TEAM
WORLD'S CHAMPIONS
1959 A.B.C. WINNER

GEORGE YOUNG | BOB HITT | BOB KWOLEK | JOE JOSEPH | BILL GOLEMBIEWSKI | ED LUBANSKI (CAPT.)

Ed Lubanski was a legendary professional bowler from Oak Park. He was a record-setting minor-league pitching prospect with St. Louis but turned to bowling full-time in 1949. His career spanned over four decades. He won a combined nine world championships and was named Bowler of the Year in 1959. Ed bowled two consecutive 300 games on television using a ball with just two finger holes. He was inducted into the ABC Hall of Fame in 1971 and the Michigan Sports Hall of Fame in 1992. Lubanski, his wife Betty, and their children were very active in the community and were longtime members of Our Lady of Fatima Church in Oak Park. Lubanski passed away in November 2010. A biography detailing his life, *King of the Pins!*, is now available. (Courtesy of Paul Lubanski.)

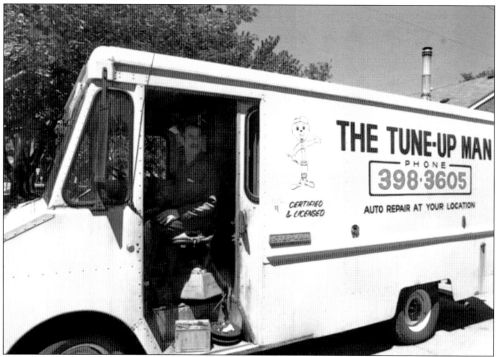

Sanford Rosenberg started his car tune-up business in 1975 after buying a non-working Red Cross truck. He repaired the truck and turned it into a mobile business doing neighborhood tune-ups and brake work. He continues the tradition by repairing cars owned by the grandchildren of his original clientele. In 1975, there were no computers or electronics in cars, but he has kept up with the times and remains a highly respected mechanic. (Courtesy of Sanford Rosenberg.)

Maurry Glusman, known as "The Ice Cream Man" in the late 1950s through the 1960s, was a recognizable figure in his white uniform with a coin changer on his belt. Maurry was born with cerebral palsy, but that did not keep him from cheerfully selling ice cream. He recounted to his cousin Alan Muskovitz that he encouraged a young Don Fagenson to pursue his dream of becoming a musician. Don (Was) became a Grammy Award–winning record producer. (Courtesy of Maurry Glusman.)

Tiger great Al Kaline offers batting tips at Pepper School. He and his wife, Louise, lived in Oak Park for the 1955 season. That year, he was the youngest player to hit three home runs in one game and win the American League batting title, and he was the 13th player in major-league history to hit two home runs in the same inning. He finished second for the league's 1955 Most Valuable Player Award.

Tiger Hall of Famer Willie Horton drives in Mayor Jerry Naftaly's car during one of his many Independence Day parades visits. Willie Horton, who has family in Oak Park, helps teach youngsters the game of baseball.

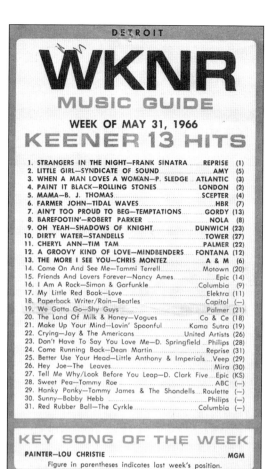

1.	STRANGERS IN THE NIGHT—FRANK SINATRA	REPRISE	(1)	
2.	LITTLE GIRL—SYNDICATE OF SOUND	AMY	(5)	
3.	WHEN A MAN LOVES A WOMAN—P. SLEDGE	ATLANTIC	(3)	
4.	PAINT IT BLACK—ROLLING STONES	LONDON	(2)	
5.	MAMA—B. J. THOMAS	SCEPTER	(4)	
6.	FARMER JOHN—TIDAL WAVES	HBR	(7)	
7.	AIN'T TOO PROUD TO BEG—TEMPTATIONS	GORDY	(13)	
8.	BAREFOOTIN'—ROBERT PARKER	NOLA	(8)	
9.	OH YEAH—SHADOWS OF KNIGHT	DUNWICH	(23)	
10.	DIRTY WATER—STANDELLS	TOWER	(27)	
11.	CHERYL ANN—TIM TAM	PALMER	(22)	
12.	A GROOVY KIND OF LOVE—MINDBENDERS	FONTANA	(12)	
13.	THE MORE I SEE YOU—CHRIS MONTEZ	A & M	(6)	
14.	Come On And See Me—Tammi Terrell	Motown	(20)	
15.	Friends And Lovers Forever—Nancy Ames	Epic	(14)	
16.	I Am A Rock—Simon & Garfunkle	Columbia	(9)	
17.	My Little Red Book—Love	Elektra	(11)	
18.	Paperback Writer/Rain—Beatles	Capitol	(—)	
19.	We Gotta Go—Shy Guys	Palmer	(21)	
20.	The Land Of Milk & Honey—Vogues	Co & Ce	(18)	
21.	Make Up Your Mind—Lovin' Spoonful	Kama Sutra	(19)	
22.	Crying—Jay & The Americans	United Artists	(26)	
23.	Don't Have To Say You Love Me—D. Springfield	Philips	(28)	
24.	Come Running Back—Dean Martin	Reprise	(31)	
25.	Better Use Your Head—Little Anthony & Imperials	Veep	(29)	
26.	Hey Joe—The Leaves	Mira	(30)	
27.	Tell Me Why/Look Before You Leap—D. Clark Five	Epic	(KS)	
28.	Sweet Pea—Tommy Roe	ABC	(—)	
29.	Hanky Panky—Tommy James & The Shondells	Roulette	(—)	
30.	Sunny—Bobby Hebb	Philips	(—)	
31.	Red Rubber Ball—The Cyrkle	Columbia	(—)	

KEY SONG OF THE WEEK
PAINTER—LOU CHRISTIE .. MGM
Figure in parentheses indicates last week's position.

Local band The Shy Guys had a hit song in 1966 called "We Gotta Go." It reached number five on the WKNR Keener charts, but the band was considered a one-hit wonder. The Shy Guys, which included Marty Lewis, Ron (Lefko) Nelson, Stu "Hirschfield" Howard, and Mark Finn, backed up the Dave Clark Five at Cobo Hall. Marty, who passed away in 2011, also produced six albums for Dan Fogelberg and worked with Jimmy Buffett, Rita Coolidge and others.

In 1969, The Oak Park High School Follies featured, from left to right, (front row) Dave Weiss, Don Fagenson, Howard Schwartz, and Mary Etta Burr; (back row) Bev Thurman and Rick Cushingberry. Weiss and Fagenson founded the group Was (Not Was). It gained popularity in the 1980s and 1990s with the album *What Up, Dog?* and the single "Walk the Dinosaur." Fagenson has received multiple Grammy Awards, including Producer of the Year in 1995.

Barber Hank Becker cuts the hair of Ray White in his Nine Mile Road barbershop. When the shop opened in 1964, there were four barbers, a manicurist, and a shoe-shine man and customers took a number for service. Red Wing Hall of Famer Gordie Howe once visited the shop. Hank said The Beatles changed things for barbers. He has long supported the community and continues to sponsor a church bowling team. (Author's collection.)

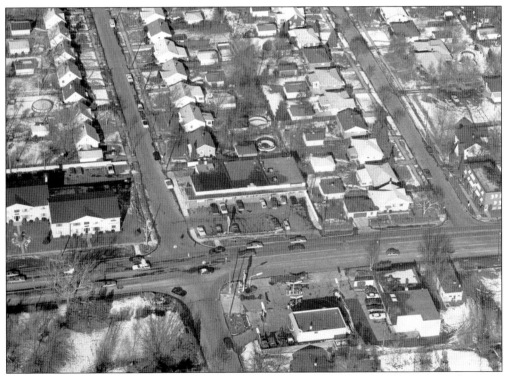

This is an aerial view of the intersection at Nine Mile Road and Rosewood Street. At the top is a strip mall owned by Tom Sesi, who also owns Pair's Food on the corner. Hank's Barber Shop and Buck's Restaurant are visible as well. Latimore's Standard Station is seen at the bottom of the photograph. The first village hall was at this corner in the 1940s, and a Little Caesar's is currently located there. (Courtesy of Hank Becker and Ray White.)

Ray White was dedicated to his family and community. A proud veteran of the D-Day invasion during World War II, he served as a US Navy Seabee and recounted his experiences during presentations at the library. Ray served on the city's election commission for more than 20 years and the board of review for more than five years until his death in 2010. He and wife, Mary, served as honorary parade grand marshals.

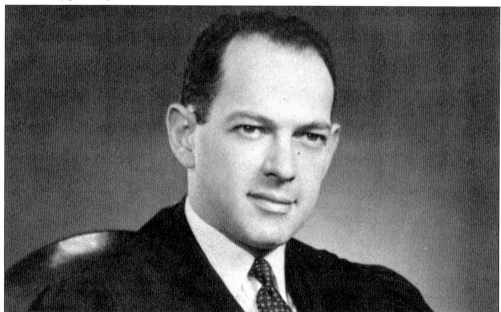

Burt Shifman was elected justice of the peace in April 1957. That same year, the city adopted the Municipal Court Act, which established the new court, and Shifman was elected the first municipal judge. He was reelected in 1961 and 1965 but resigned in 1968 to become the city attorney.

Five

RECREATION AND LIBRARY PROGRAMS

In 1990, the motto "We Have Something For Everyone" was officially adopted by the recreation department. The concept began with Oak Park's master plan in 1951, which included a civic-center complex in the area bordered by Coolidge Highway, Oak Park Boulevard, Church Street, and Northfield Avenue. Forty-three acres of land were developed as Major Park. In 1981, it was renamed David H. Shepherd Park to honor the long-serving incumbent mayor who died that year. In 1955, voters passed a proposed bond issue that generated the funding necessary for land acquisition and the costs of constructing the community center building, municipal swimming pool, two ball diamonds, tennis courts, picnic areas, parking facilities, access roads, water facilities, and shelters.

By 1958, the population was more than 34,000, and Oak Park was identified as the fastest-growing municipality in the country. In 1973, the recreation department received a National Gold Medal Grand Award "for excellence in park and recreation services and management." Modern lights were installed at the Major Park tennis courts in 1975. In 1976, a new wing of the community center opened that included the senior center, then known as the Going Like 60 Club and later called the 50-Up Club. Programming for handicapped individuals and a day care for children were added in 1979. Extensive improvements were made to the pool in 1981. In 1983, FunFest, a program including the city's Independence Day celebration, was inaugurated.

The Oak Park Library looked the same for 60 years until a major rehabilitation occurred in 2011–2012. The original library was built at a cost of $200,000, had approximately 7,000 square feet of space, and held 15,000 volumes. By the 1990s, the library housed more than 80,000 items. With the help of residents, grants, generous donors, volunteers, Friends of the Library, and the Arts and Cultural Commission, it evolved into a cultural center and entered the age of computers. Under the direction of library directors Leo Dinnan, John Oliver, Larry Wember, and John Martin, the library grew from the bookmobile to a modern, computerized library.

In a January 1966 photograph, Gene Archibald is shown working on the coal car for the city park. Gene, along with Marty Barkovich, constructed the original train. Bill Chase, Dan Craig, and others have rebuilt and maintained the train through the years.

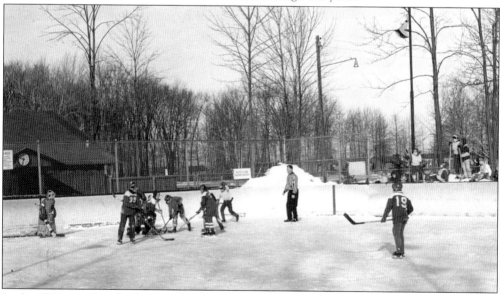

In the 1950s, outdoor hockey was a very popular sport. The Oak Park Hockey Association was formed in 1970. Tuesday night was hockey night in Oak Park with the Peewee, Bantam, and Midget travel teams playing to huge, friendly home crowds. The Detroit Red Wings practiced frequently at the arena in the mid- to late 1970s when their home rink at Olympia Stadium was unavailable.

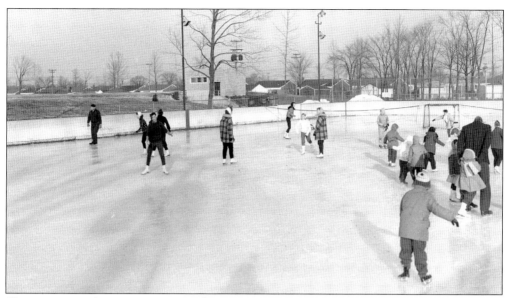

Skating was a favorite pastime. The recreation department offered skating lessons at the outdoor rink.

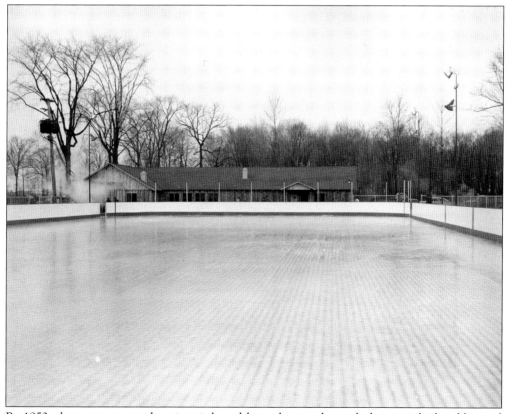

By 1953, there was an outdoor ice rink and log cabin in the park, but very little additional construction took place until citizens approved a bond issue in 1955. That key vote provided the resources for rapid and complete development of the central recreation complex.

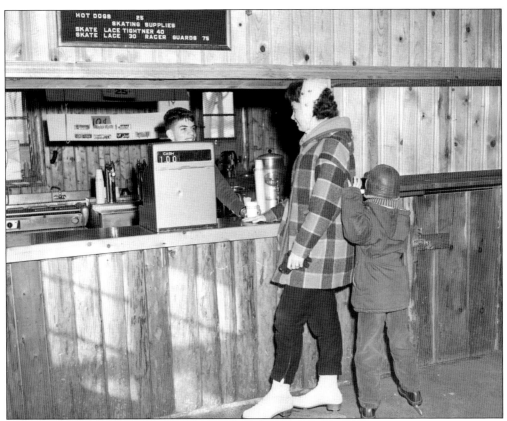

The concession stand inside the ice arena was the place to hang out and get 25¢ hot dogs and hot chocolate.

These are some of the original recreation staff members in 1956–1957. There were so many children and adults registering for programs of all sorts that a large staff of employees and volunteers was needed. The summer months were particularly busy for the department.

In 1957, this rectangular excavation shows the shape of the new Oak Park Municipal Pool. In the foreground, note the start of the pool-house construction. Some of the residents are using the city's first municipal tennis courts, complete with old-fashioned overhead lights, in the left background.

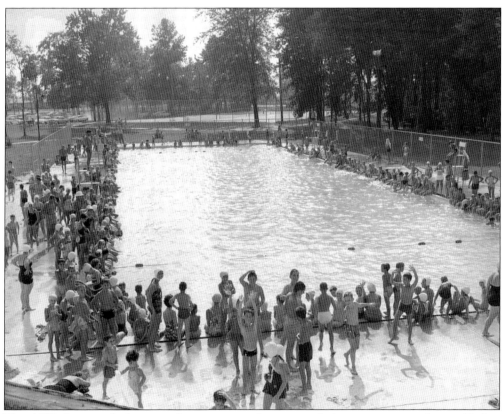

This 1957 photograph shows residents enjoying the new pool. A concession stand was added in 1963. Thanks to a recreation bond issue passed by voters in 1980, an entirely new municipal pool was opened in June 1981 at the original site.

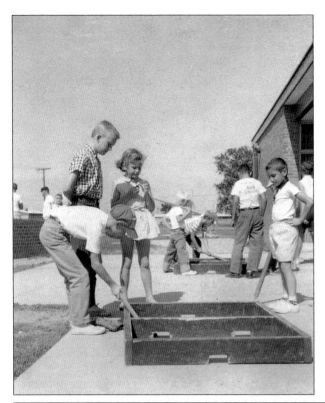

The first summer for the recreation department's day-camp program, as well as the birth year of the community center and municipal pool, was in 1958. Many activities were offered during the summer months, both inside and out. The photograph on the left shows a box hockey game. The image below shows bumper pool, which was available inside the community center.

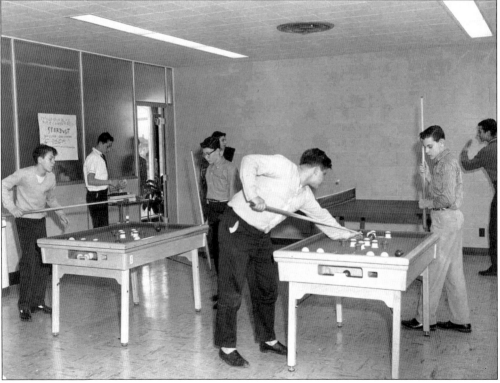

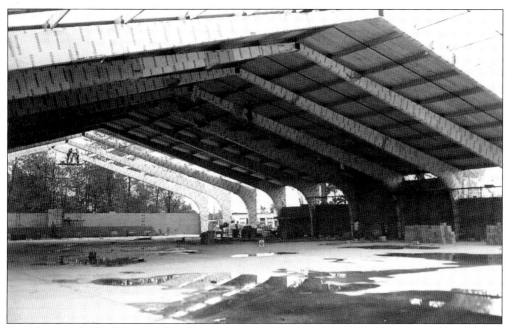

Seen here in 1971, the ice rink is being converted to an enclosed facility. It would serve as a multipurpose building with handball courts, exercise room, and sauna baths. It would eventually be rented to private hockey club leagues.

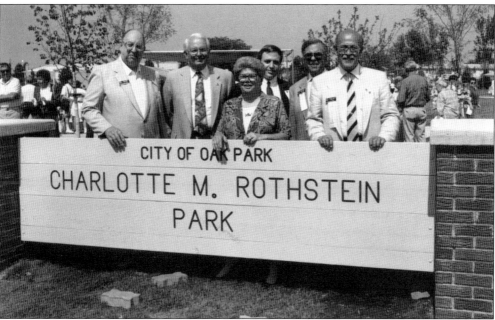

Charlotte Rothstein served Oak Park as a council member (1973–1981) and mayor (1981–1991). Before she left office, the city council recognized her many years of distinguished service by naming one of the plaza decks over I-696 the Charlotte M. Rothstein Park. The dedication program included family, friends, and officials from throughout the region. Pictured here from left to right are Councilman Lou Demas, Deputy County Executive Pat Nowak, Mayor Rothstein, Mayor Pro Tem Jerry Naftaly, Councilman Art Frohlich, and Councilman Ray Abrams.

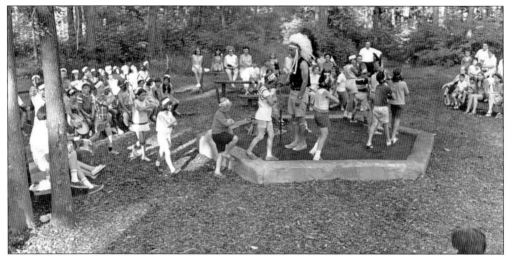

In the 1970s and 1980s, Camp KiliKawa was created. The camp leader wore a Native American headdress, and the campers circled the fire pit for traditional dances and folklore. They would also hike through the woods and play in the old tires. Over the years, interest in this theme decreased, and the fire pit became overgrown with weeds and was demolished. New ordinances prohibited the fire pit in the middle of the woods.

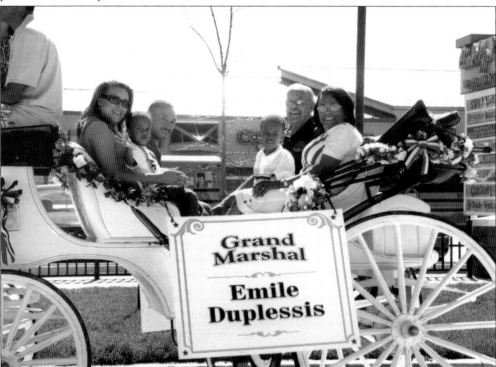

Annually, city residents and businesspeople are given the honor of appearing as grand marshals of the Independence Day parade. Emile Duplessis, a longtime member of the zoning board and the mayor's blue-ribbon commission, who would also be a future councilman, is pictured with his family. His grandson William is with the driver, and from left to right are his daughter Cheryl Haithco, grandson Kyle, son Phillip, grandson Cameron, Emile, and his wife Jean.

By the early 1960s, the recreation department was extraordinarily busy. This was sign-up day for youth programs in 1962. There were no computers to make things faster and easier, so hundreds of young people stood in lines for hours to enroll in the activities of their choice. The department's participation level reached a half-million registrations in the calendar year of 1963.

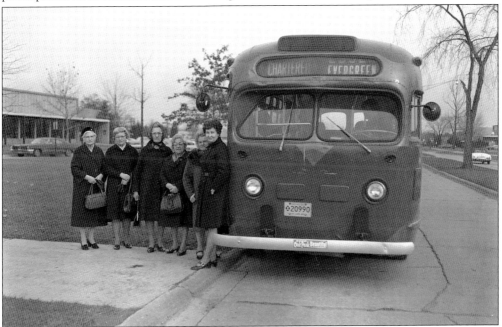

The ladies are getting ready to board the bus for one of the popular day trips offered by the recreation department. Recreation employee Betty Griffith, leaning against the bus, helped coordinate the trips for residents. The photograph was taken in front of the community center on Oak Park Boulevard.

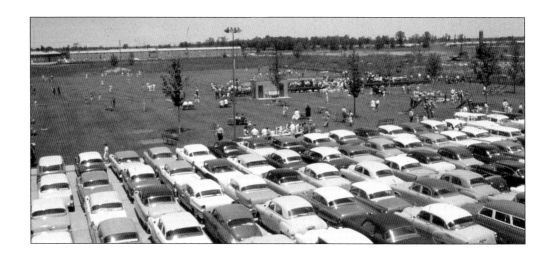

The Oak Park Optimist Club dedicated the new baseball field behind Koepplinger's Bakery on Eight Mile Road on May 22, 1954. A year earlier, Koepplinger employees donated their spare time to help clear the field of stones and weeds.

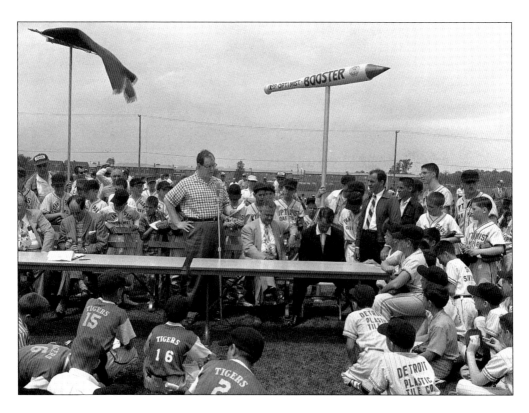

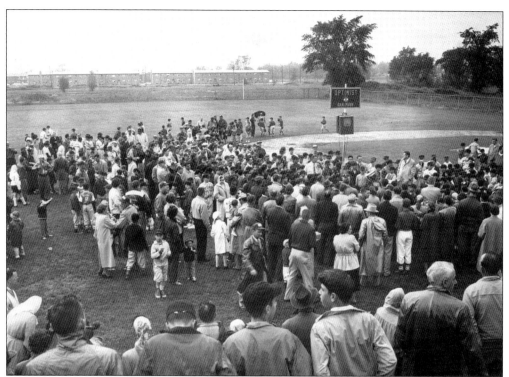

More than 400 people attended the dedication program that included remarks by Mayor Richard Marshal, bakery owner Karl Koepplinger, and baseball commissioner R.J. Alexander, a councilman and member of the Oak Park Optimist Club. The fans were treated to appearances by hockey great Ted Lindsay, Red Wings coach Tommy Ivan, Heisman Trophy winner Leon Hart of the Detroit Lions, and popular WJBK-TV sportscaster Al Nagler. Nagler was one of Detroit's most recognizable sports announcers in the 1940s and 1950s and called play-by-play for the Detroit Red Wings, preceding Budd Lynch. Also on hand for the festivities was Michigan Secretary of State Owen J. Cleary. Karl Koepplinger said, "If the boys learn fair play and sportsmanship, I will feel rewarded."

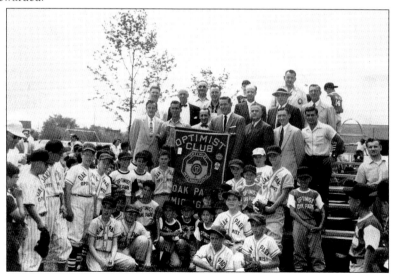

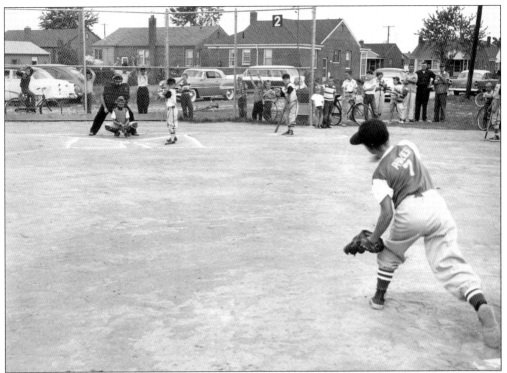

In the mid-1950s, the recreation department combined with the Oak Park Optimist Club to provide uniforms to each player on the 25 teams. Teams played at baseball fields throughout the city. Jim Finn and Bill Naftaly performed umpiring duties for the city. Here, Naftaly calls the balls and strikes.

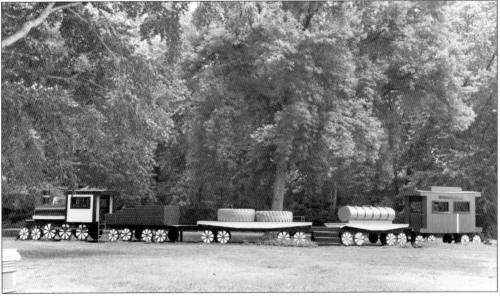

The train has been a focal point in the city park for generations. Having long since achieved the status of "local icon," it has taken generations of children on countless journeys to imaginary destinations. (Author's collection.)

In 1987, Oak Park secured a commitment that the upcoming I-696 project would include construction of two large parks to help mitigate the impact of the expressway on the community. The decks fully span the width of the highway's eight lanes. Mayor Pro Tem Gerald E. Naftaly asked city council to officially name a plaza park in honor of outgoing Mayor Rothstein. In 1990, Charlotte Rothstein Park and Victoria Park opened. (Photograph by Benyas Kaufman.)

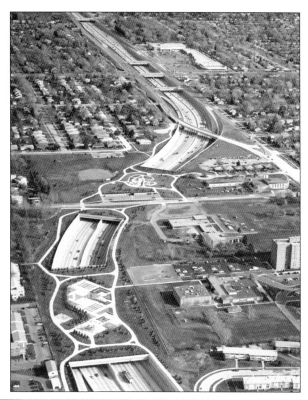

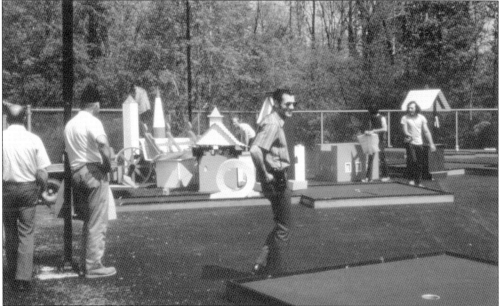

In this c. 1969 photograph, city workers build the original Putt in the Park mini-golf course. Pictured from left to right are Frank Davis, Marty Barkovich, Dan Craig, and (far right) Jack Camhi; the other men in the background are unidentified. The original course was located between CP2's right field and the tennis courts; it was reconditioned in the 1990s. In 2010, it was completely rebuilt as a new course next to the municipal pool.

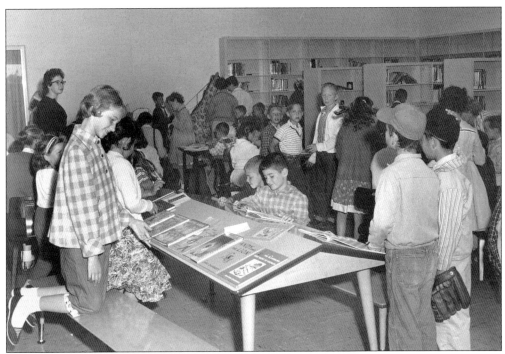

The reading table was a new feature in the late 1950s for the brand-new library. It allowed the children to sit alongside each other and share books.

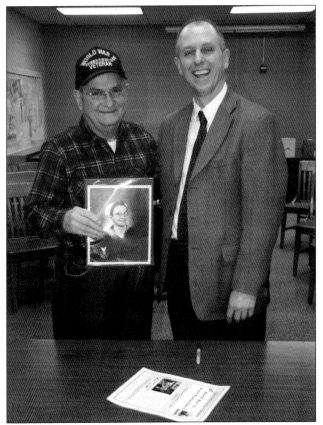

Library director John Martin (right) introduces guest speaker Ray White. John was instrumental in obtaining many institutional grants and arranging a wide variety of programs. He teamed with Cary Loren and Colleen Kammer, owners of Oak Park's independent bookstore Book Beat, to bring award-winning authors to Oak Park.

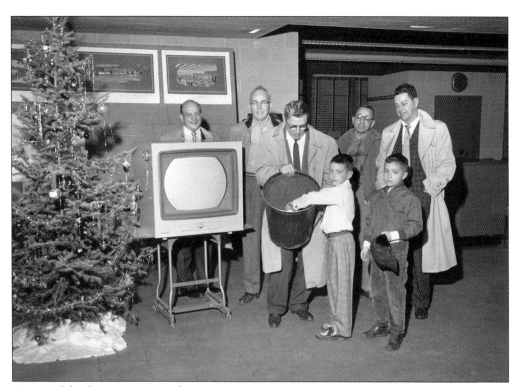

At one of the first programs at the library, a prize drawing included a brand-new television.

Pulitzer Prize–winning poet Gwendolyn Brooks (1917–2000) read from her works during "Writers Live at the Library." Brooks published her first poem at age 13, and by age 16 she had about 75 published poems. She was appointed poet laureate of Illinois in 1968 and poet laureate consultant in poetry to the Library of Congress in 1985, and she was presented with the National Medal of Arts in 1995.

Guest author and resident Irwin J. Cohen (*Tiger Stadium* and *Jewish Detroit*) is known as "Mr. Baseball." Cohen, a writer and photographer, worked at Tiger Stadium when the team won the 1984 World Series. Another Arcadia author, Paul Vachon (*Forgotten Detroit* and *South Oakland County*), presented his books to patrons, as did former resident Susan B. Katz (*Tyler's Hill*). Another noted resident is distinguished professor and author Sid Bolkosky. (*Harmony and Dissonance*).

A wide variety of concerts and musical programs are held throughout the year. Concerts have been sponsored through the generosity of individual and corporate gifts.

Grace Naftaly and son Jerry pause for the camera while dedicating the new, large-print collection of books in honor and memory of William "Bill" Naftaly, husband and father. The family donated funds to begin a collection to honor Bill's dedication to the library and community center. Included in the collection are books on tape, CDs, and videos for the hearing impaired, as well as large print books for the visually impaired. The collection continues to grow thanks to the family's continued support.

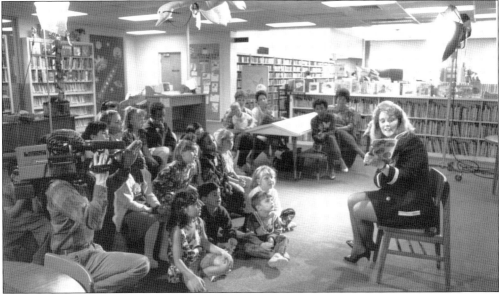

Many volunteers, including celebrities, have taken time to read to the children. Channel 7 news reporter and anchor Mary Conway is shown reading to the kids as part of "Reading Month." Fox 2's meteorologist Rich Luterman made a guest appearance on the city's cable program *Castle Cable Fables*. Paul Gross, a channel 4 meteorologist, also made a guest speaking appearance.

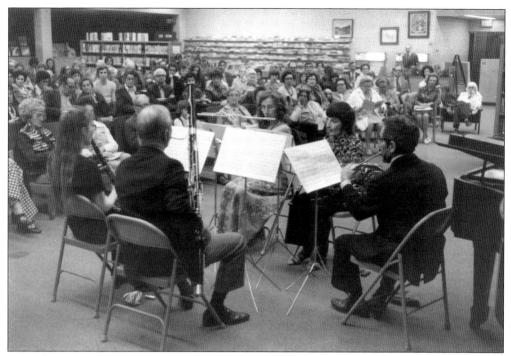

The library has been the setting for many programs, attracting audiences of all ages and interests. Musical programs included the Count Basie Orchestra and Russian mezzo-soprano Irina Mishura.

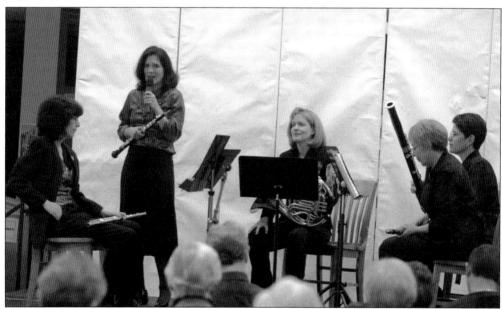

Lillian Dean (second from the right) has performed with her ensemble at the library many times to rave reviews. She has worked with the Warren Concert Band and the Royal Oak Symphony and has brought many of those talented musicians with her to Oak Park; oboist Ann Lemke is one of those musicians. Lillian also shares her talents as a master composer and coordinates many seminars for healthy lawns in Oak Park and the surrounding area.

Six

CHURCHES
AND SYNAGOGUES

A major theme in the 1950s was "Brotherhood." The city's annual report noted that the population of about 35,000 was almost equally divided among Catholics, Jews, and Protestants. The Oak Park Council of Community Organizations (OPCCO) was formed with 40 of the city's religious and community organizations. Its goal was to face interfaith problems head-on and mold a community of different faiths into one with common objectives. The OPCCO included PTAs, churches, and synagogues and Kiwanis, Lions, and Oak Park Goodfellows clubs. Cub Scout and Boy Scout troops were also involved, as well and civic groups, including the symphony and civic chorus. Leaders of the organization included Bud Leve, Ralph Jayne, Beverly Benaim, Steve Kazup, Richard Silverman, Bob Fitzerman, Dr. Leon Lucas, Jack Stein, Dennis Aaron, and Maurice J. Noble. PTA representatives included Linda Blatt, Aida Cutler, and Marilyn Cohen. Fr. Paul Chateau, Rev. George Dunstan, Rabbi Stanley Rosenbaum, Rabbi Milton Rosenbaum, and Rabbi David Nelson represented churches and synagogues. The OPCCO sponsored music concerts to highlight better appreciation and understanding of all faiths through music. B'nai B'rith honored Mayor Richard Marshall and other Oak Park citizens with a Brotherhood Award for outstanding achievement in South Oakland County. Pastor Jesse DeWitt of Faith United Methodist Church on Scotia Road also received the award for his contribution to interfaith relations. Ministers and rabbis exchanged pulpits and conducted services during Brotherhood Week. When Our Lady of Fatima Church was razed by fire, several faiths joined with Fr. George Parzych to restore the church. Adjacent to the Charlotte Rothstein Park is the Jewish Community Center (JCC) on the A. Alfred Taubman Jewish Community Campus. Opened on Ten Mile in 1956, the center, which was expanded in 1993, now includes fitness facilities, an aquatics center, gymnasium, restaurant, and meeting rooms. The campus also includes senior apartments and assisted-living services.

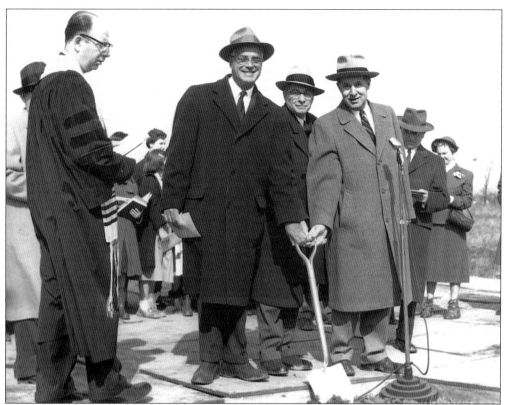

Temple Emanu-El, the Suburban Temple, was founded in 1952 as the first reform Jewish Temple in Oakland County. Bernard Lieberman owned land on Ten Mile Road between Coolidge Highway and Greenfield Road. He donated three acres of land and offered to sell additional acreage. Bulldozers began clearing the 15-acre site the same week. The photograph above is of the ground-breaking ceremony attended by, from left to right, Rabbi Frank Rosenthal, W. Schmier, B. Kaatz, Bernard Lieberman, unidentified, and Dorothy Weiner. The image below was taken in 1956, when construction was nearly complete. (Above by Robert Stotter, below by Win Brunner; both courtesy of Don Cohen and Temple Emanu-El.)

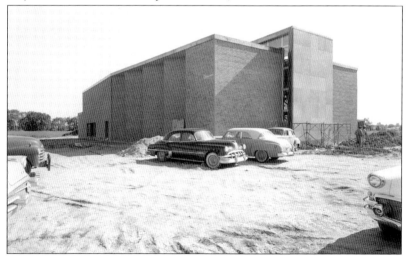

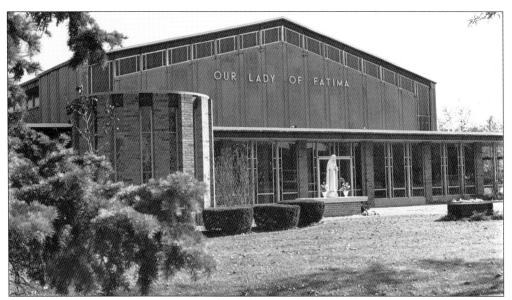

Our Lady of Fatima Church was formed in May 1950. Fr. Boleslaus Parzych, the founder of the parish, conducted the first Mass at Clinton School on June 15, 1950. Members broke ground for the new church in September. Construction of the 10-room schoolhouse began in October 1953 and was later staffed by Sisters of St. Joseph. The school closed in June 1971. On February 17, 1953, a short circuit in the organ wiring caused a fire, resulting in an estimated $100,000 of damage to the church. Reverend Parzych oversaw an interfaith drive to help rebuild the church. Fr. Paul Chateau was assigned to the parish in March 1972. In November of that year, the new parish hall was dedicated to Msgr. John F. Bradley, pastor of the church from June 1967 until his untimely death in 1971. (Courtesy of Father Paul Chateau and Our Lady of Fatima.)

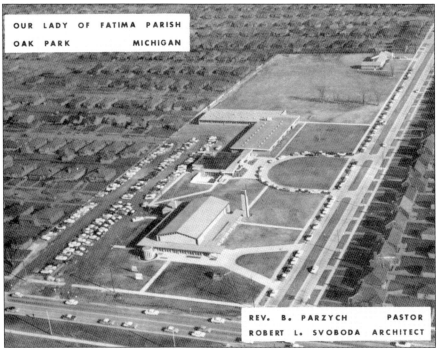

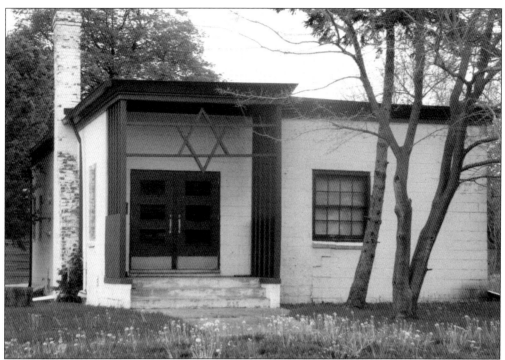

In his book *Echoes of Detroit's Jewish Communities*, author Irwin J. Cohen writes about Rabbi Solomon H. Gruskin. Rabbi Gruskin presided over services at three synagogues. On Friday nights and Saturday mornings, he served at two Detroit synagogues, the one located at Humphrey and Holmur Streets and the B'nai Zion on Seven Mile Road near Mendota Avenue. On Saturday afternoon, he would walk to B'nai Zion on Nine Mile and Avon Roads, the smallest synagogue building in the suburbs. (Author's collection.)

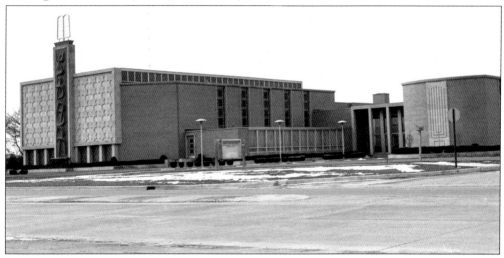

Congregation B'nai Moshe would be one of eight Jewish houses of worship and one of two conservative synagogues in Oak Park when it was dedicated on Ten Mile Road and Kenosha Street in 1960; the other was Congregation Beth Shalom on Lincoln. B'nai Moshe moved out of Oak Park in 1992. The landmark 10 Commandments symbol remains at the top of the building. (Photograph by Benyas Kaufman.)

Seven

EVENTS AND PROGRAMS

Over the years, many special events have been held in the city. Parades and fireworks brought out the largest crowds. There were ceremonies to honor volunteers and employees. Concerts in the park offered a wide variety of musical performances, including the 20-piece Air Force jazz ensemble Night Flight. Alexander Zonjic and Friends performed several times. Oak Park hosted the official touring program, 30 Years of Rock 'N' Roll, with Donnie Brooks. Among those featured were Otis Day and the Knights, Badfinger's Joey Molland, Tiny Tim, Dennis Yost and the Classics IV, Cub Koda, and The Gentrys.

One of the lasting benefits to the city was the addition of a Michigan State Police post. The State of Michigan was considering a new location in the combined Oakland-Macomb County area. Gov. Jim Blanchard had a review team examine many potential sites, including two in Oak Park: one at the former site of Weber Brothers Greenhouse on Ten Mile Road near Woodward Avenue, and the other at Ten Mile Road and Kenosha Street, a site that the state had bought for the I-696 Freeway. After support from the governor's committee and then state police colonel Michael Robinson, Oak Park was awarded the post to be built at the Kenosha site. Before construction began, however, a new governor, John Engler, was elected. He called for another review of potential sites, and a second round of heavy lobbying began. Mayor Jerry Naftaly sought the assistance of Oakland County prosecutor L. Brooks Patterson. Patterson was able to secure a meeting with Governor Engler's review team for a presentation. Oak Park prevailed, and the post was built.

The Bicentennial Commission Time Capsule was dedicated on November 16, 1975, and will be opened 100 years from that date. Interred are bulletins from nine churches and synagogues, a city calendar and newsletter, a school district report, yearbooks (1975) from the three school districts, and copies of local newspapers. Also included are a pair of blue jeans, a menu from Stafford's Restaurant, tapes from Oak Park High's radio station (WOPR), and a bagel. (Author's collection.)

In 1976, a commission was appointed to celebrate the American bicentennial. The list of the commissioners on this plaque includes Ruben Weiss. Ruben performed on the *Soupy Sales Show* and was the voice of Detroit Dragway, proclaiming "Sunday! Sunday at Detroit Dragway!" He was also Santa Claus for the J.L. Hudson's Thanksgiving Parade for many years. His son David (Was) formed the musical group Was (Not Was) with fellow Oak Parker Don Fagenson. (Author's collection.)

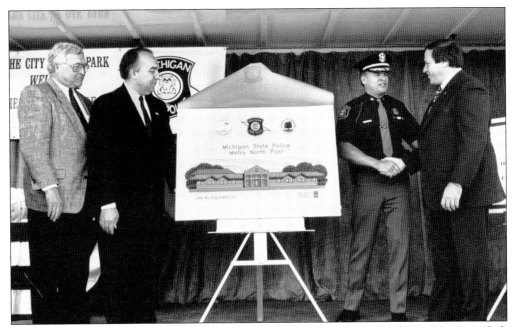

The dedication ceremony of the Michigan State Police (MSP) Metro North Post No. 21 in Oak Park brought many dignitaries from the state and local area. Pictured from left to right are Oakland County executive L. Brooks Patterson, Gov. John Engler, MSP director Col. Michael D. Robinson, and Mayor Jerry Naftaly. The post was opened in 1997. Recently, the post was expanded to include more troopers and now covers Wayne, Oakland, and Macomb Counties.

This photograph includes members of the recreation advisory board from the late 1980s. Pictured are, from left to right, (seated) Phil Cutler, Mike Rich, and Linda Blatt; (standing) Jim Emanuel, Al Urpsis, Roy Vultaggio, and Jerry Naftaly. The board members review programs and fees with staff members and make recommendations to the city council.

Seen here are members of the cable television commission and staff. The commission reviewed cable programming in the city and made recommendations to the city council. Pictured from left to right are Sheldon Roth, Richard Silverman, Mel Newman, unidentified, John Carlson, Rita Steele, Zack Davies, Ray Abrams, Marx Cooper, and Sedric Sawyer.

Annually, the City of Oak Park honored the resident volunteers and staff who serve the community on boards, committees, and commissions. Approximately 200 people attended the dinner event, which included entertainment and the presentation of pins for five or more years of service. The program was the city administration's way of saying thank-you for all they do to help review programs and services for the department staffs and residents. Due to recent budget conditions, the dinner has been eliminated.

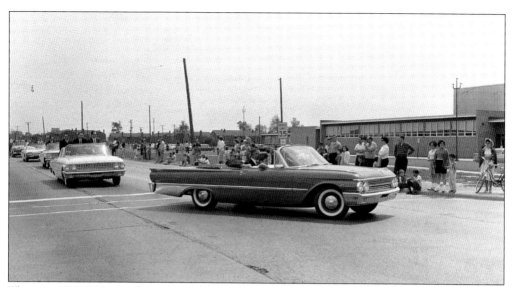

The city of Oak Park takes great pride in the annual Independence Day parades. Above, the parade is heading north and about to turn left onto Oak Park Boulevard. In the early 1990s, several longtime residents, including Sharon and Paul Levine (who would later be elected an Oak Park city councilman) and Lou and Joy Landau, approached recreation director Al Urpsis and volunteered to redesign the parade and return it to how it was in the "old days." The city council created the new Independence Day Commission, and, working with the staff, increased participation and attendance. A "Fun Day" in the park began with the Kiwanis pancake breakfast, the parade, and then refreshments, game booths, and entertainment. Together with the annual fireworks display, it created the largest two-day crowd in the city. Through the years, a wide array of entertainment has been offered, including such crowd-pleasing performers as jazz flutist Alexander Zonjic, The Contours, Sha Na Na, Tiny Tim, Steve King and the Dittilies, and Peter Noone of Herman's Hermits.

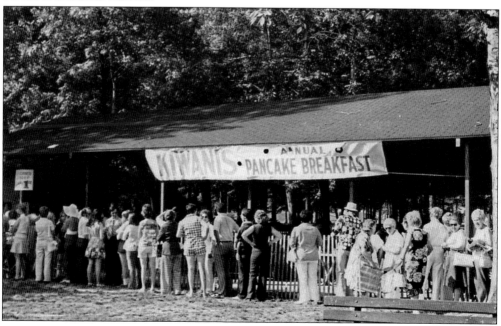

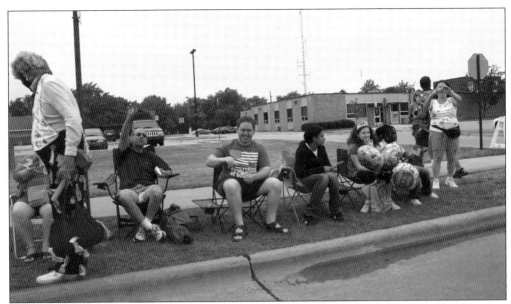

Pictured at left, LuLu the Clown (Lou Landau) has appeared in more than 40 Independence Day parades in Oak Park. For one of them, he and his wife Joy were honorary grand marshals. Together, they are known as "the Candy Lady" for the candy and toys they gather and annually donate to a home for boys. Longtime residents, they have provided their time, energy, and expertise to the city as members of many boards and commissions.

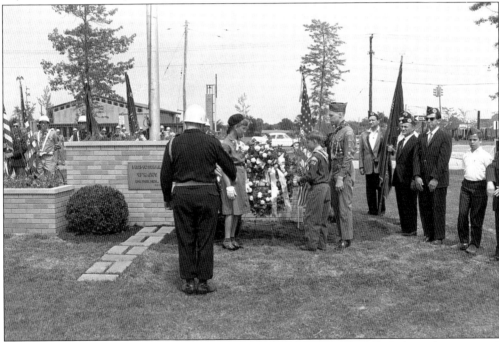

The Veterans of Foreign Wars and the Jewish War Veterans of Oak Park dedicated a memorial flagpole in front of city hall, and the ceremony included scout troops. When the parking lot was expanded, the flagpole and the worn and cracked brick base were removed. A temporary flagpole was placed to the east of city hall. Our Lady of Fatima Church is in the background.

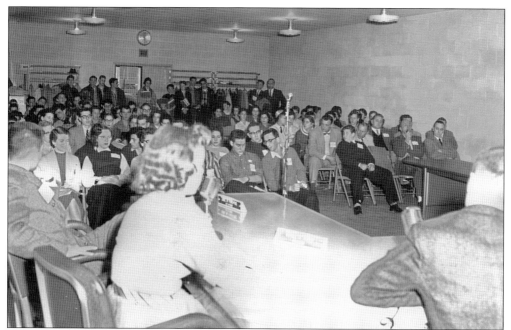

One of the more interesting programs the city conducted was Youth Government Day. Working with the school districts, students would vie for positions in the legislative, administrative, and judicial branches in the city. Students would work with their counterparts during the day, attend a lunch or dinner program, and attend the city council meeting. Students are seen here attending the city council meeting around 1956.

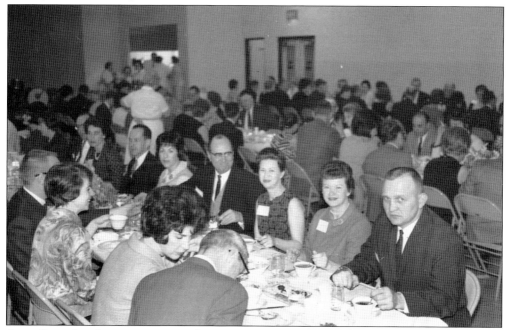

Attending a luncheon program in the community center around 1960 are, facing the camera from left to right, municipal judge Burt Shifman, his wife Sue, city manager Virgil Knowles, his wife Norma, Margaret Leonard, and public safety director Glen Leonard.

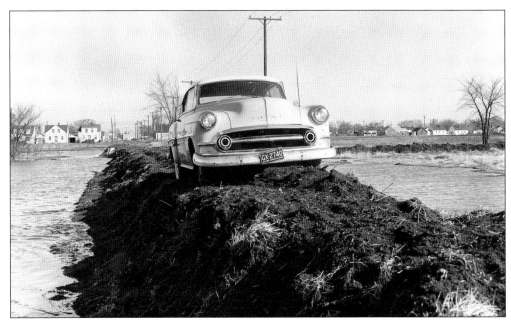

Oak Park had been hard-hit many times by floodwaters that filled basements and made many roads impassable. Joined by the neighboring cities of Southfield, Berkley, and others, they looked for solutions to keep floodwaters from crossing Greenfield Road into the eastern communities. Oak Park built a system of three dikes in an effort to hold back storm waters. A new junior high school was about to be built in the middle of the "artificial lake," according to the city engineer. A proposed $30 million, 12-town system of relief drains was more than two years away from being completed. The drain (underway in the photograph below) was expanded in 2005 at a cost of $132 million with a capacity of 130 million gallons. The Twelve Towns Drain was renamed the George W. Kuhn Drain in 2006 in honor of the former Oakland County drain commissioner.

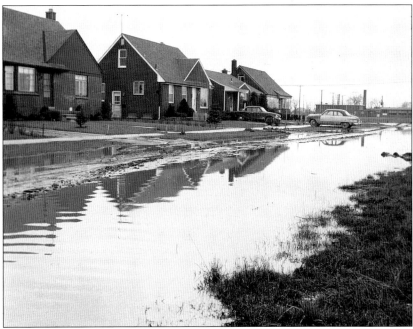

The Lustron House was a mass-produced, porcelain-enameled home made entirely from steel, and Oak Park had several of them. It came in subdued shades of yellow, gray, aqua, or salmon. Mr. and Mrs. Joseph King bought their Lustron House in 1950 when there was only a dirt road and a farmhouse. According to their daughter Anita, the King's—featured in the 2003 Emmy-winning film *Lustron: The House America's Been Waiting For*—were attracted to it because it required very little maintenance. (Author's collection.)

The City of Oak Park receives the Present Crisis Award from the National Association for the Advancement of Colored People (NAACP), Southern Oakland County Chapter, after residents' concerns were expressed to the public safety department. Communication and cooperation negated the concerns. Showing the award are public safety officer Jim Luxton (second from left), and from left to right, director Bob Seifert, Mayor Jerry Naftaly, and public safety officer Kevin Edmonds.

In 1992, Oak Park received the first-place Municipal Achievement Award for Charlotte Rothstein and Victoria Parks from the Michigan Municipal League (MML). Mel Newman prepared the winning entry, which featured the large aerial that appears on page 99. The League Awards Committee stated the plazas are "naturally attractive connecting points between neighborhoods north and south of the freeway." Shown displaying the award are, from left to right, Ray Abrams, Art Frohlich, Jerry Naftaly, and Sandy Gadd.

Iris Mickel and Officer Jim Luxton organized an award-winning program called Vertical Eye Watch (VEW). Residents at the Federation Apartments, overlooking Rothstein Park, watched over the park and reported suspicious activities to public safety. Apartment complex administrator Mickel and city representatives presented the concept at the National League of Cities conference. From left to right are Willie Horton, Iris Mickel, Mike Seligson, Mayor Jerry Naftaly, Dan Fitzpatrick (kneeling), Art Frohlich, Ray Abrams, and Officer Jim Luxton.

On December 27, 1977, *Daily Tribune* photographer Craig Gaffield, while stopped at a red light on eastbound Ten Mile Road at Coolidge Highway, saw a flame from the rear of a gasoline tanker truck. The tanker had hit a car, overturned, and burst into flames, killing a pedestrian. Gaffield earned an Associated Press Award for his photograph of this horrific event. (Courtesy of Craig Gaffield and the *Daily Tribune*.)

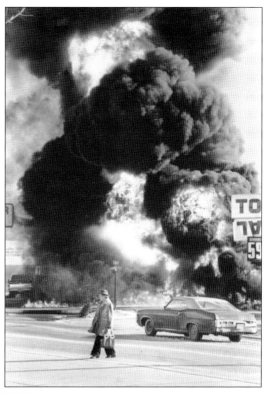

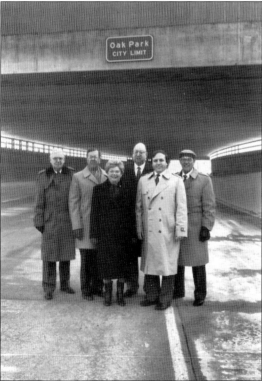

In December 1989, Mel Newman and Nate Peiss arranged for this photograph under the "City Limit" sign. From left to right are Aaron Marsh, Art Frohlich, Charlotte Rothstein, Lou Demas, Jerry Naftaly, and Ray Abrams. This final section of I-696, which runs through Oak Park, opened to traffic on December 14, 1989, at 5:00 p.m.—and at 6:21 p.m. experienced its first automobile accident. Years later, a tanker explosion at one of the decks resulted in all flammable cargoes being banned from this segment of the expressway.

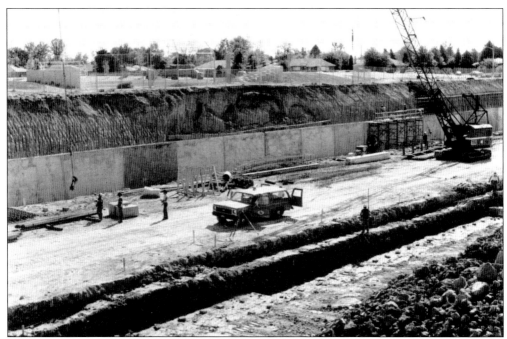

This photograph shows the I-696 construction in progress, with Victoria Park in the background. The park had to be shifted during the construction phase, as reconfigurations were done on the expressway and the park. Homes were also removed, and some were actually transported to other sites within the city and surrounding area.

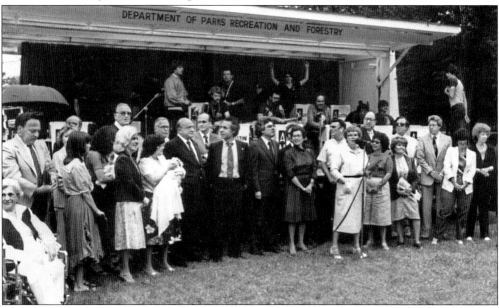

Mayor Charlotte Rothstein leads the introductions of local officials at a program on the north side of the newly named David H. Shepherd Park. Distinguished guests included Dennis Aaron, Joe Forbes, Jack Faxon, and Doug Ross. City council members are on the right side of this photograph, and the family of the late mayor David Shepherd is on the left. The Austin Moro Band performed at the event.

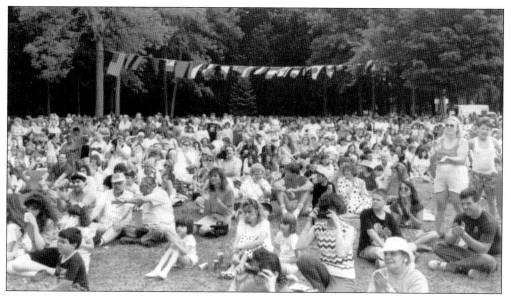

The Ethnic Festival, shown here, brought out very large crowds. Initiated by Mayor Charlotte Rothstein and the ethnic task force committee members, the annual event was staged for more than 10 years on the north side of Shepherd Park. Thousands of residents and non-residents enjoyed a day of music, entertainment, and cultural activities, representing dozens of ethnic groups. Oak Park is said to be home to over 80 different ethnicities.

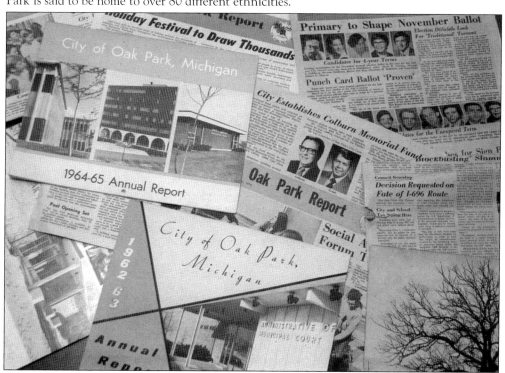

Communication from the city to the residents is extremely important. Mel Newman has expertly prepared such publications as the Oak Park report and annual calendar for more than two decades. He uses these reports to share programs and services available in the city.

121

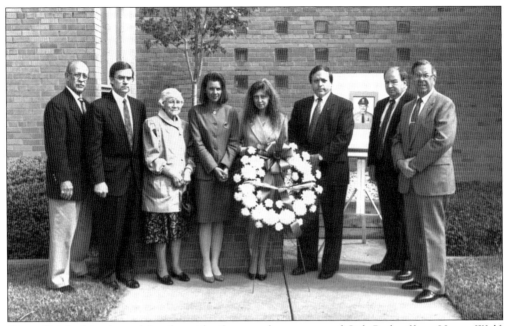

City officials, friends, and family paid tribute to the memory of Oak Park officer Henry Wolf, who was killed in the line of duty on May 21, 1973, at the age of 27. He left a wife, Lynda, and, daughter Laura. Pictured from left to right are Raymond M. Abrams, Deputy Director Steve Fairman, Joyce Wolf (Officer Wolf's mother), Laura Wolf, Lynda Wolf, Jerry Naftaly, Director Bob Seifert, and Art Frohlich.

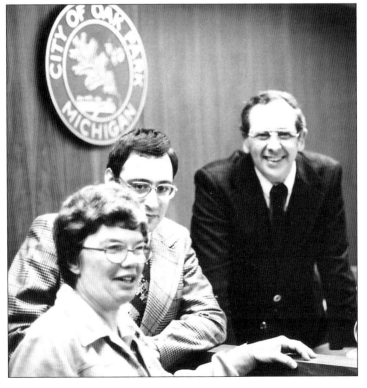

This 1975 photograph shows, from left to right, Charlotte Rothstein, Irwin Cohen, and David H. Shepherd. Rothstein served as a council member from 1973 to September 1981 and mayor from 1981 to 1991. Councilman Cohen served from 1971 to 1973 and 1975 to 1979. Shepherd served as a council member from 1957 to April 1971. He won a special election to fill the mayor's seat vacated by Joe Forbes, who became a state representative. Shepherd, for whom the largest city park is named, served as mayor from 1971 until his death in September 1981.

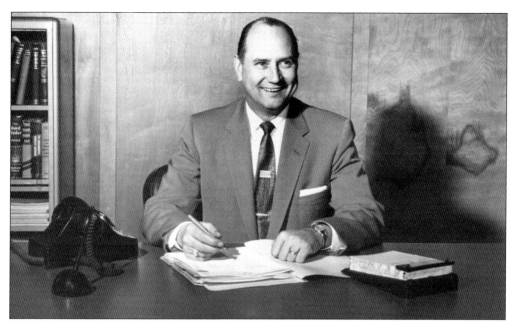

Virgil Knowles served as the city manager of Oak Park from 1957 until his death on April 16, 1967. He was a talented, diplomatic, lighthearted gentleman. He was a loving family man who left a legacy of wisdom and morality that made Oak Park a better community. (Courtesy of Steve Knowles.)

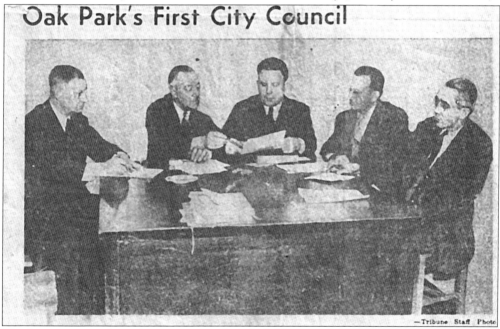

Oak Park's First City Council

—Tribune Staff Photo

The first city council members are pictured in 1945. They are, from left to right, James F. Fisher, Harry G. Cousins, Mayor John J. Molloy, Fred B. Yehle, and Paul T. Comerford. The mayors who served after Mayor Molloy were Robert Crinnian (1947–1949), Gerald P. Kent (1949–1951), Richard Marshall (1951–1959), Raymond J. Alexander (1959–1967), Joseph Forbes (1967–1971), David H. Shepherd (1971–1981), Charlotte Rothstein (1981–1991), and Gerald E. Naftaly (1991–2011). Joe Forbes was elected as state representative in 1971. (Courtesy of the Molloy family.)

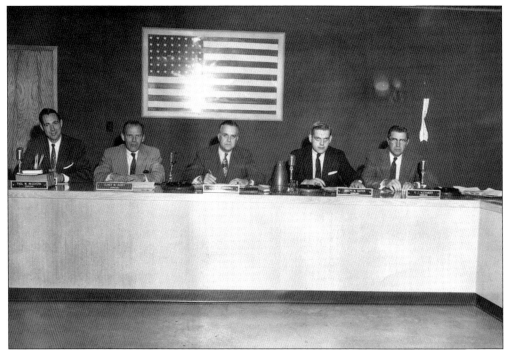

This 1956 photograph shows the city council in the council chamber. Pictured from left to right are Paul McGovern, Elmer Barry, Mayor Richard Marshall, Joseph Suiter, and R.J. Alexander.

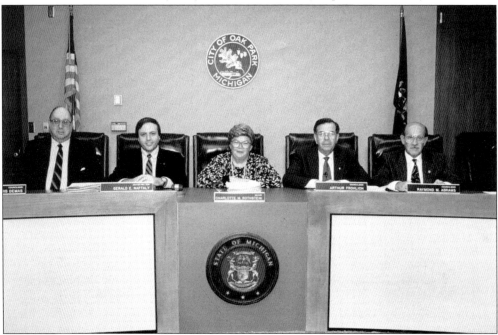

Here is an image from 1989 that shows the city council in a refurbished council chamber. This is also the main courtroom for the 45B District Court used by Judges Ben Friedman and Marv Frankel, who succeeded Municipal judge Burt Shifman. Picture from left to right are Louis Demas, Jerry Naftaly, Mayor Charlotte Rothstein, Arthur Frohlich, and Raymond M. Abrams.

Larry and Judy Vardon's home was featured on the program *Extreme Makeover, Home Edition* in 2004. Larry and Judy, who are both deaf, are parents of Stefan (then 14) and Lance (then 12), who is blind and autistic. Stefan wrote to the show, and the Vardon home was selected. The crew completely renovated the house. Over 5,000 friends and neighbors applauded in sign language as the Vardons arrived to see their renovated home. Academy Award–winning actress Marlee Matlin presented a check from the Starkey Foundation for Stefan's education. (Courtesy of Hyperion.)

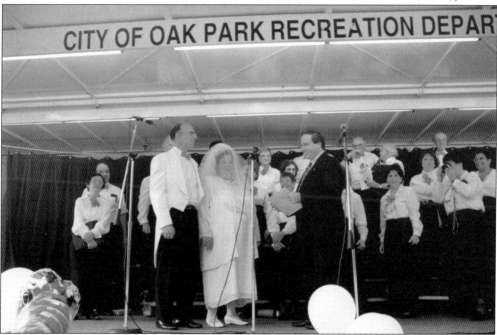

Michigan mayors were given the authority to solemnize marriages in 1972. Mayors Shepherd, Rothstein, and Naftaly created personalized ceremonies. Most weddings were performed at city hall, but other venues were also popular: one was held on top of the Oak Park Hill, and another was broadcast live on Dick Purtan's show on WCZY. This June 1998 photograph shows the Oak Park Chorus Concert. Mayor Naftaly also renewed vows for couples, including Jerry and Shirley Schlussel.

This is the new marquee at Nine Mile Road and Coolidge Highway. From the old days of a single message, changed manually by public works staff, this new sign offered multiple messages and font combinations. The shopping center owners pledged to donate an updated, larger sign to highlight the city and showcase the shops, but they have since changed their plans.

The city welcome sign at Coolidge Highway and Eight Mile Road was featured on one of the city's annual calendars. It serves as a friendly greeting and invitation to see what Oak Park has to offer.

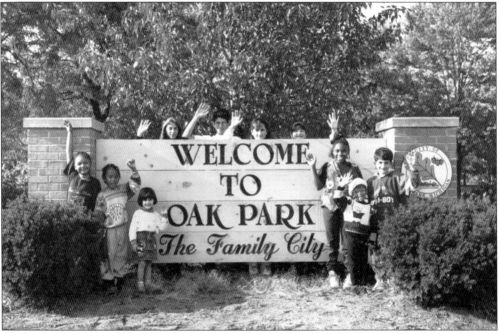

The library received an upgrade both inside and out when voters passed the extension of a construction bond. The exterior of the building had not changed since it was built in 1957; the interior had only been minimally updated. In 2011–2012, the library was upgraded and remodeled and will now serve the residents for many years to come.

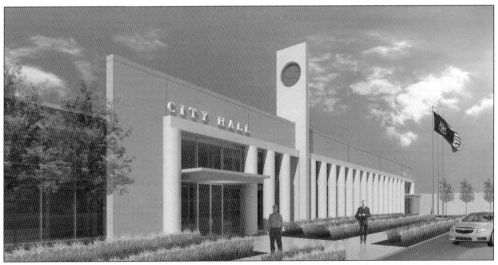

This is a rendering of the "new" city hall. In 2010, voters approved a $13-million bond issue to construct city hall and the attached public safety building. The city council officially approved The Glenford S. Leonard Public Safety Building to honor the first public safety director. The Mason Samborski and Henry Wolf Law Enforcement Center will honor the memory of the two officers slain in the line of duty. The Gerald E. Naftaly Municipal Complex will honor the longtime mayor.

Discover Thousands of Local History Books Featuring Millions of Vintage Images

Arcadia Publishing, the leading local history publisher in the United States, is committed to making history accessible and meaningful through publishing books that celebrate and preserve the heritage of America's people and places.

Find more books like this at
www.arcadiapublishing.com

Search for your hometown history, your old stomping grounds, and even your favorite sports team.

Consistent with our mission to preserve history on a local level, this book was printed in South Carolina on American-made paper and manufactured entirely in the United States. Products carrying the accredited Forest Stewardship Council (FSC) label are printed on 100 percent FSC-certified paper.

MADE IN THE USA